Living Shrines
of Uyghur China

Living Shrines of Uyghur China

Photographs by Lisa Ross

Essays by Beth Citron,
Rahilä Dawut, and Alexandre Papas

The Monacelli Press

To Mom and Dad
Who taught me to
treasure imagination,
always forgive
and
love unconditionally.
This is for you.

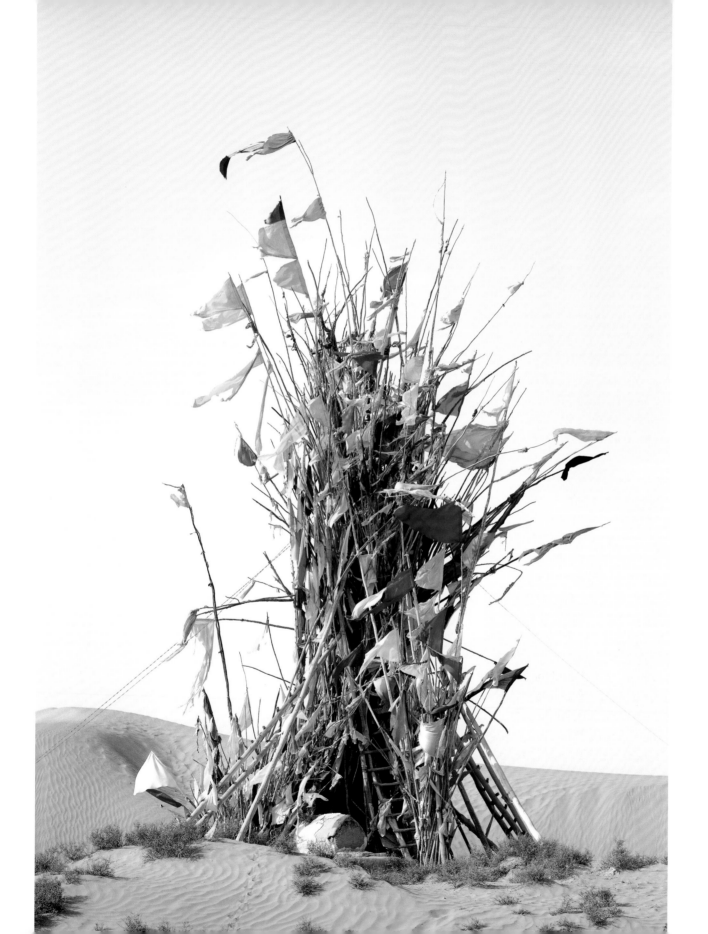

Preface

Shao Ma was Hui, Chinese Muslim. He had begun to have a feeling for the kinds of landscapes that interested me, even though we had no language in common. He was quiet and thoughtful. He pointed into the desert. There seemed to be a footpath in the sand, forged by use over time. Following his nod, I walked in, over small sand dunes and then a large dune. Colors began to reveal themselves. In the distance I could see what looked like wooden cribs or rafts, cresting on dry land, animated by colored flags beating in the wind. As I neared the markers, there seemed to be animals with arms and legs stuck atop tall wooden posts. As I continued to walk farther, the spirit of this place became all consuming. Everything had been created by hand; nothing had the feeling of a machine. Each object I passed was carved, sewn, built, or placed with intention.

Although no one else could be seen, there was evidence that many had walked here recently. Spirit vibrated. After walking a kilometer an ancient mosque revealed itself, as if emerging from the sand, birds circling around the minaret. A long history was evident. Yet I had little idea of where exactly I was or how I had gotten there.

Meeting a young Parisian by the name of Alexandre Papas a week later on a rickety minibus would make returning to that desert possible. Two years would pass before we traveled together in the summer of 2004, as an artist and a scholar, I with my camera and he as a historian of Central Asian Islam able to speak and write the Uyghur language. During our two-year correspondence, Alexandre shared the history of the region and meaning behind the photographs I made that day when Shao Ma pointed into the desert.

The story of my relationship to mazârs (holy sites) is one of fate and possibly faith. With each step I took, another door opened. When people ask me, "How did you choose this?" the most suitable answer is: "It chose me." The truth is I had been feeling very drawn to deserts. In the three years prior I had visited the Sahara twice and Sinai once. Often an artist will arrive at a place and it becomes their home, somewhere all of the channels open up and they find they can create freely without hesitation. The Taklamakan Desert and its surrounding oasis villages and cities became this for me.

When Alexandre and I returned to the Taklamakan, it was with a book in hand, a hagiography he had come across in his research. This pilgrim's guidebook, written in Uyghur and published in 2001, described eighty-six *mazârs*. It provided information about these holy sites, such as approximate locations, histories, the names of saints, and descriptions of the miracles they performed. This book became our bible and guide. On the book jacket was a small photo of the author, a woman who would later lead me far beyond the pages of her dissertation.

We traversed the Xinjiang Uyghur Autonomous Region, managing to visit more than twenty-five *mazârs*. We traveled by foot, donkey cart, bicycle, mini-van, taxi, train, and bus. Because Alexandre could communicate in the Uyghur language, we were assisted, directed, fed, and carried by many along the way. Our journey to each *mazâr* was a unique pilgrimage.

The School of Oriental and African Studies in London had organized a conference on Uyghur culture to be held in fall 2004. When I learned that Rahilä Dawut (the author of the hagiography we used) was presenting, I contacted the organizer. We were granted a twenty-minute presentation. It was then that I met Rahilä; she was in disbelief that her book had so great an effect on the lives of two foreigners. After I shared the images I had made, she explained that she did a lot of fieldwork and could benefit from learning more about photography. She asked if I wanted to return and travel with her. In May of 2005 we met in Urumchi and traveled together for six weeks.

Working with Rahilä was like moving from the outside to the inside. The travel was still long and rigorous; the *mazârs* continued to be remote. But wherever we went we met with friends or family and were always invited in. I learned to bring gifts wherever we went. When we visited the parents of one of her students, I asked what I could bring as a gift. She held a bag of crystallized sugar, what I call rock candy and the Uyghurs call *nawat*. Everyone needs sugar; it's expensive, never goes bad, and can always be re-gifted. Hospitality is deeply rooted in Uyghur culture. I came to see it as integral to maintaining balance and a sense of community. Rarely permitted to leave someone empty-handed, I was once given a bag of fresh boiled eggs.

Somehow all of the experiences Rahilä and I shared brought me closer to the holy sites. I began to see the markers that people created for their family members as portraits of those who had passed but also of those who were still living. We arrived at one large *mazâr* that held an annual festival the day before the big pilgrimage, because Rahilä wanted to get permission to photograph. I'd come here before with Alex when there were a few people, and I had also come alone. It was the site Shao Ma silently directed me to, three years prior. Tomorrow thousands would arrive, something I could never begin to imagine, and yet, returning helped establish an intimacy with the landscape. There were magicians, a crowded arena for an ancient form of wrestling, tightrope walking, food stalls, storytellers, musicians, hats for sale, religious beggars, and the smell of lamb cooking, while all day long buses, donkey carts, and taxis arrived carrying more people. After spending time at the edge of the desert in the midst of the festivities, people began the walk into the desert, stopping to pray at all of the different markers along the way. There were many markers, and they were spread out. Some of the elderly were brought in

by donkey cart, and camels were also available for those who needed a ride. Everywhere people could be seen burying themselves and each other in the sand, which is known to cure and prevent rheumatism and arthritis.

The work I made while traveling with Rahilä had deepened, but the time with her only created a greater desire to return and continue developing this body of work. I made a conscious decision to remain apolitical, in large part because I wanted to respect and protect everyone with whom I worked. Religious sites on their own are fraught with controversy in the People's Republic of China, and the politics of the Xinjiang Uyghur Autonomous Region are both disconcerting and unnavigable. Modernization, change, and development are occurring at a rapid pace. My focus has remained on the physical markers created in the landscape, markers that have defined and identified Uyghur culture for centuries.

Lisa Ross, May 2012

Pilgrimages to Muslim Shrines in Western China

Alexandre Papas

What Is Holiness?

This question should be the first asked by scholars, artists, or whomever approaches a holy site—usually called a *mazâr* in Central Asian languages, from the Arabic—especially in the Muslim world, where saints and their shrines, more than mosques perhaps, arouse the most widespread, dramatic, and powerful experience of religious devotion. Often, trying to answer this question, the scholar consults classical spiritual texts and/or interviews pilgrims as well as religious specialists (*mazâr* guardians, mullahs, etc.), but the artist—the photographer in particular—is probably the person best able to capture impressions, instants, sensations. While the scholar may not feel the emotion behind what he understands academically, the artist may not understand the historical significance behind what she sees. Yet both ponder the same question.

Lisa Ross, photographer, Rahilä Dawut, ethnographer, and I, historian, tried not to consider this question from separate angles: we tried to seek one syncretic answer together as we visited holy places throughout the Xinjiang Uyghur Autonomous Region in Western China. Rahilä and I felt that our scholarly explanations of these sites alone could not convey what pilgrims experienced during pilgrimage, while Lisa thought that some historical or ethnographic knowledge was necessary background for approaching holy places, both artistically and intellectually. The photographer could expose the silent side of religious life while the scholars could explain the somewhat mysterious facts and deeds that accompany it. This book is an attempt to introduce *mazârs* in a comprehensive way that employs both perspectives.

Lisa's photographs go far beyond the usual approach: visiting photographers taking picturesque images of exotic people and places with little explanation, or scholars composing illustrated academic publications for other scholars. Based on knowledge provided both by Rahilä and by me, Lisa was able to reach isolated places only locals frequent, and she also was able to learn about what she was witnessing. Conversely, we two scholars began to observe more carefully as well, to get closer in a sense: the object of our study was to exceed the

emotional depth of our earlier experiences. Thus, we three were compelled to literally put ourselves in pilgrims' shoes, to let our travels progressively become more like pilgrimages than duties. Lisa's photographs do not merely illustrate this process and the knowledge we gained; they summarize the ideas behind them, they convert them into meditation. This book, therefore, becomes the narrative of a discovery of holiness.

Historical Background

The Islamization of Western China started in the tenth century with the conversion of rulers of the Turkic Qarakhanid dynasty. Brought by merchants and missionaries (mostly Hanafi Sunni but including Shii) coming from Central Asia or Persia, the new faith progressively replaced shamanic beliefs, Christian Nestorian communities, and above all, Buddhism, which was spread across the Tarim Basin.[1] Throughout the history of Islam in the region, believers have venerated the heroes of this religious heritage, that is to say convert kings, great proselytizers, holy fighters, learned men, pious zealots, mystical figures, and so on. These saints of Islam in Western China not only aroused the devotion of the masses but received material as well as spiritual support from the elite. Considered "friends of God" (Ara. *walî*, pl. *awliyâ*),[2] or intermediaries between Allah and the faithful, the saints became a major part of Turkestanese society, and they were respected, listened to, and praised during their lifetimes and afterward. They played different societal roles: they were believed to be able to cure, to help, or to punish people; also to have the power to determine the course of events. For instance, in the early fourteenth century, after the oases had been damaged by the invasion of the Mongols, it is recorded that the saints "contributed to the rehabilitation of sedentary life in Eastern Turkestan."[3] Very influential at the Chaghatayid court, they fostered the (re)construction of villages and the repair of the irrigation system. In the late seventeenth century, at the time of the Yarkand Khanate, we find a dynasty of Sufi saints, namely the Naqshbandi Khwâjas, who seized power, reorganized religious life, and tried to set up a theocracy based on Sufi values and ideals.[4] During the mid-nineteenth century, with a large group of followers and allegedly guided by God, Muslim saints like Khwâja Rashîd al-Dîn launched several holy wars (*ghazât*) against the Qing conquerors.[5] To sum up, the saints and their descendants have occupied a central place in the history of Eastern Turkestan from the medieval period to the present day.

Genealogical charts and legal documents both show that *mazârs* retained their religious authority and their socioeconomic importance, at least at the local level, from generation to generation until the early twentieth century.[6] For example, in a Reformist newspaper published in the 1930s, the seventeenth-century *mazâr* of Âfâq Khwâja in Kashgar is noted for attracting large revenues from endowments.[7] Later in the century, the case of the Naqshbandiyya Jahriyya Sufi lineage presents several "modern" saintly shrine custodians, or *shaykhs,* such as Tâhir Khân Khwâja (d. 1947), Tukhsun Îshân (d. 1997) or 'Ubayd Allâh (d. 1993).[8] Some of these Sufi saints or their ancestors are buried in family shrines where small groups of disciples still go

on pilgrimage.[9] Even after the critical year of 1949, when Xinjiang was incorporated into the People's Republic of China, the dedication to saints continued despite atheist campaigns, the secularization process, and reformist Islamic opposition to saint veneration in the region.[10] Another sign that the current populace intends for the memories of saints to be maintained is that fact that *shaykhs* keep oral legends alive about their life and their deeds.[11] Although, needless to say, the province's absorption into the People's Republic of China caused a certain decline of religious trends and institutions, there is clearly a continuing interest in the cult of saints.

Types of Muslim Shrines in Xinjiang

Veneration of saints is performed in the countless mausoleums located throughout the Xinjiang Uyghur Autonomous Region. Size and nature distinguish different types of *mazârs*.[12] According to the standard Uyghur descriptions,[13] the main monumental shrines, composed of one tomb or several, a mosque, and a building for mystics (*khanaqâh*), are the following (in alphabetical order): 1) Altunluq *mazâr* in the old city of Yarkand, 2) Apaq Khoja *mazâr* in the village of Häzrät near Kashgar, 3) Imam Asim *mazâr* close to the village of Jiya in Lop County, 4) Imam Jä'färi Sadiq *mazâr* to the north of Niya, 5) Ordam Padishahim *mazâr* in the southeast of Harap, near Yengisar County, 6) Tuyuq Khojam *mazâr* (also called Äshabul Kähf) at Yalquntagh in Pichan County, 7) Sutuq Bughrakhan *mazâr* in the village of Suntagh, near Artush. This last site has become a museum and has lost its spiritual dimension. However, individual pilgrims still visit; the adjoining Friday mosque is also functional. These additional shrines cannot be counted among the official mausoleums, since there are no pilgrimages today and no remaining religious character, although they are authentic historic sites: 1) Mähmud Qäshqäri *mazâr* in the village of Opal, east of Kashgar, 2) Qomul Wangliri *mazâr* at the entrance of the old city of Qomul, 3) Yüsüp Khas Hajip *mazâr* in the city of Kashgar. Aside from these large holy complexes, pilgrims visit innumerable "secondary" shrines frequently, smaller places with simple architecture, often situated in remote rural areas. A last type of shrine is the small local *mazâr*, which is often just a single tomb, or sometimes only a sacred spring or cave, with a rudimentary shrine structure.

Rituals of Pilgrimages

The pilgrimage to a holy tomb, called a *ziyârat*, literally "visit," is to be distinguished from the obligatory pilgrimage to Mecca (*hajj*). They are clearly not equivalent in the religious consciousness of Muslim believers. However, as we shall see, visits to shrines share several similarities with the *hajj*. If not mandatory, a *ziyârat* is recommended as a meritorious deed (*sawâb*).

In Xinjiang, as elsewhere in the Muslim world, *ziyârats* take place at various times and occasions. People visit saints at religious festivals like *mawlid* (a birthday celebration for a holy figure, especially the Prophet Muhammad or of a Sufi saint) and *qurban* (when an animal sacrifice is made as a rite performed during the Great Festival (*ʿayd al-kabîr*); at specific religious periods in the year like *ramadân* (the fasting month), *muharram* (the sacred month) and *barat* (a night of worship during the eighth month of the Islamic calendar); starting seasons, in spring mostly; on specific days, particularly on Fridays, after the Friday prayer and sermon at the mosque.[14] The usual ritual acts at shrines consist of: 1) prayers of request to God (*duʿâ*); 2) the devotional circumambulation (*tawâf*); 3) less frequently, animal sacrifices (sheep, but also goats, chickens, and other birds) and various offerings seeking the intercession of the saint in order to obtain a divine favor. There is no particular fixed order for these different rituals.

The most popular religious practices are an offering and a vow. To glorify the saint and ask for his blessing or protection, pilgrims bring various ritual objects to his burial place. An important ceremony peculiar to Xinjiang is the "pole fixation" (in Uyghur, *tugh körüshtürüsh*, lit. to make poles face each other): people place a wooden pole (often a tall branch) at the foot of a tomb and tie colored flags (*ʿalam*) to the pole.[15] There are usually several *tugh* above a tomb. The flags and all the small pieces of material tied to the poles or to the trees or bushes nearby are basically ex-votos, but they are also believed to scare away evil spirits. One may find many other ritual offerings near a saint's tomb: goat horns or bones, horse tails, sheepskins, handsewn talismans, metal crescents, incense sticks, bricks, pebbles, etc. Another popular practice, apparently exclusive to Xinjiang (in the context of the Muslim world), regards the making of dolls: women create little dolls (*qorchaq*) from scraps of cloth that they leave on shrines to signify to the saint their wish for pregnancy. These figurines are also used by shamans to cure children and to assist or to chastise people in love affairs.[16] In general, *mazârs* in Xinjiang are known for curing disease and assisting with fertility. Certain shrines even have specific treatment functions. For instance, one is visited specifically to cure skin diseases, mainly warts[17]; at another, people leave old shoes to heal leg or foot problems.

Pious visitors enjoy various spiritual as well as secular activities during the *ziyârat*. Since the cult of saints is intimately associated with Sufism, it is not surprising that some pilgrimages integrate Sufi performances, in particular collective ceremonies of psalmody and dance (*dhikr-samâʿ*) and devotional singing sessions (*munâjât*). On the other hand, during the most popular pilgrimages, often attended by thousands of visitors, communities set up trade fairs and festivals. Such was the case at the Apaq Khoja *mazâr* and at the Ordam Padishahim *mazâr* (between Kashgar and Yarkand).[18] Most of these festivals are now prohibited in China, yet an annual pilgrimage like the one to Imam Asim *mazâr* remains an extraordinarily large and lively event.[19] From Wednesday through Friday throughout the month of May the shrine is surrounded by bazaar booths and food stalls, and a wide range of activities like camel riding, wrestling, tightrope walking, magic shows, storytelling, and musical performances are available.

The Cult of Saints, Cultural Patrimony, and Identity

Today, the status of continued pilgrimages to Muslim shrines in Xinjiang is uncertain. The state, anxious to struggle against any "illegal religious activities," tends to tighten its control over shrines and visits to shrines, going so far as to ban certain important pilgrimages (as it did with the Ordam Padishahim *mazâr* in 1997), but saint veneration is still very widespread throughout Xinjiang among Uyghurs and the other Muslim minorities in the region (mainly Hui, Kazak, and Kirghiz). This is the result of long-term as well as more recent processes; the cult of saints in the Tarim Basin is a religious institution in the sense that it has historically been promoted by local political and religious authorities, Sufis in particular, insofar as it fulfilled various socioeconomic functions. In other words, the cult of saints became—as in many other parts of the Muslim world—a central, omnipresent aspect of religious life. Such an institution does not vanish in a few decades. And, clearly, this is no longer the time of atheist campaigns in China. Indeed, the successive political upheavals that occurred after 1949 did not put an end to the cult in the Xinjiang Uyghur Autonomous Region, even though they led to a relative reshaping of rituals and beliefs. Moreover, since the 1980s and the new attitude of the Chinese state toward minorities and religion, a very large number of Muslim shrines have been endowed with the status of "cultural patrimony site" (*mädäniyät yadikarliq orun*), that is to say an administrative label that enables the protection and, occasionally, restoration of their mausoleums. It implies that, from now on, *mazârs* belong officially to the cultural heritage of the Muslim minorities in Xinjiang; they are admitted to be an essential part of their identity.[20]

Such recognition of a Muslim religious tradition is not without danger. When defined as a patrimonial object, a shrine could lose its spiritual function by being declared inaccessible to pilgrims and pious visitors for reasons of preservation. This kind of "museification" process has already taken place at several important mausoleums. Worse, since the late 1990s, many Xinjiang *mazârs* have started to be listed in guidebooks for casual travelers to the region; several "cultural patrimony sites" were indeed recently turned by Han private firms into tourist attractions.[21] The emergence of this third interest, namely tourist companies (the two others being the Muslim minorities and the state), is increasing the rate of forced secularization and taking the control of *mazârs* away from religious groups. Many holy sites now ask for an entrance fee, which the majority of local citizens just cannot afford; every visitor also has to fill in a registration book, giving his or her full name, nationality, address, and occupation. The violent events of August 2008 (four attacks on Han policemen by small, isolated groups of Uyghurs) led to a reinforcement of controls and regulations, notably around *mazârs*. Such rules complicate, if they do not completely repress, the pilgrimages.

Nevertheless, from the perspective of the Xinjiang Muslim minorities, the picture is, perhaps, less black than it first appears. This concentrated attention on holy places by multiple interests—i.e. the Muslim minorities, the state, and the tourism business—also reactivates the historical meaning of saints, that is, their traditional and multifaceted role in the history of

Central Asian societies. Whether venerated or disregarded, the saints are indisputably historical presences who call for a social, political, and religious response. They represent the heroes of a prominent faith and the very ideals of its believers. They remain an irreducible part of the Muslim minorities' identity, linking them not only to the local cultural environment but, beyond, to the legendary history of Islamization and to the mythical geography of the Muslim world (*dâr al-islâm*). From the believers' point of view, even if politics or economics are able to affect the shrines, they are not able to affect the saint. It should be reinforced that, in Islam, the saint transcends burial and is not considered deceased—the Muslim "friends of God" never die.

1 Haji Nur Haji and Chen Guoguang, *Shinjang Islam Tarikhi* [History of Islam in Xinjiang] (Beijing: Millätlär Näshriyati, 1995), 42–64.

2 For a definition, see *The Encyclopaedia of Islam*, 2nd ed., s.v. "walî." Categories of saints listed in Abdullajan Keräm, *Islam Dini Izahliq Lughiti* [Annotated Dictionary of Islam] (Urumchi: Shinjang Khälq Näshriyati, 2003): 505–15.

3 Ho-Dong Kim, "Muslim Saints in the 14th to the 16th Centuries of Eastern Turkestan" *International Journal of Central Asian Studies* 1 (1996): 316

4 On the Khwâjas, see Alexandre Papas, *Soufisme et politique entre Chine, Tibet et Turkestan* (Paris: Jean Maisonneuve, 2005).

5 Masami Hamada, "De l'autorité religieuse au pouvoir politique: la révolte de Kûca et Khwâja Râshidîn" in *Naqshbandis. Cheminements et situation actuelle d'un ordre mystique musulman*, ed. M. Gaborieau, A. Popovic, Th. Zarcone, 466–67 (Istanbul-Paris: Isis, 1990).

6 Jun Sugawara and Yayoi Kawahara, *Mazar Documents from Xinjiang and Ferghana* (facsimile) (Tokyo: Research Institute for Languages and Cultures of Asia and Africa, Studia Culturae Islamicae No. 83, 2006), 19–20.

7 *Yengî Hayât*, "Awqâfghä Khiyânät" [Fraud in Religious Endowments], No. 22, December 6, 1934.

8 Thierry Zarcone, "Sufi Lineages and Saint Veneration in 20th Century Eastern Turkestan and Xinjiang" in *The Turks*, 536 (Ankara: Yeni Türkiye, 2002).

9 Thierry Zarcone, "Le culte des saints au Xinjiang de 1949 à nos jours" *Journal of the History of Sufism* 3 (2001): 146–48.

10 Alexandre Papas, "Les tombeaux de saints musulmans au Xinjiang. Culte, réforme, histoire" *Archives de Sciences Sociales des Religions* 142 (2008): 51–56.

11 Several samples of these legends (in Uyghur language with a Japanese translation) can be found in Jun Sugawara, "Mazar Legends in the Kashghar Region" in *Islamic Sacred Places in Central Asia: The Ferghana Valley and Kashghar Region. Silkroadology* 28, 67–77 (Nara: Research Center for Silk Roadology, 2007); also some legends in English in Jianxin Wang, *Uyghur Education and Social Order: The Role of Islamic Leadership in the Turpan Basin* (Tokyo: Research Institute for Languages and Cultures of Asia and Africa, Studia Culturae Islamicae No. 76, 2004): 252–62.

12 Naturally, what follows is not an exhaustive list of *mazârs* in Xinjiang. I visited most of the places mentioned in this list between 2001 and 2011, including during three fieldwork trips with Lisa Ross. I keep the Uyghur orthography for their name.

13 See, among others, Adil Muhämmät Turan, *Shinjang Mädäniyät Yadikarliq Jäwhärliri* [Jewels of the Cultural Patrimony of Xinjiang] (Urumchi: Shinjang Pän-Tekhnika Näshriyati, 2006):174–91. The best description remains Rahilä Dawut, *Uyghur Mazarliri* [The Shrines of Uyghur People] (Urumchi: Shinjang Khälq Näshriyati, 2001).

14 Änwär Tursun Äpändi, *Uyghur Örp-Ädätliridin Örnäklär* [Examples of Uyghur Customs] (Urumchi: Shinjang Khälq Näshriyati, 2007): 265–70.

15 Thierry Zarcone, "Le culte des saints au Xinjiang de 1949 à nos jours" *Journal of the History of Sufism* 3 (2001): 151–52. In the rest of Central Asia, *tugh* appear at Muslim shrines, but in a far reduced quantity and not stuck together.

16 Abdurähim Habibulla, *Uyghur Etnografisi* [Ethnography of the Uyghur People] (Urumchi: Shinjang Khälq Näshriyati, 1993): 397–400. It seems that rituals using dolls existed also in the Ferghana Valley, see Ljudmila Anatol'evna Chvyr', *Obrjady i Verovanija Ujgurov v XIX–XX vv* [Rituals and Beliefs of the Uyghurs in the 19th–20th Centuries] (Moskva: Izdatel'skaja Firma "Vostochnaja Literature" RAN, 2006): 183.

17 Interestingly, there is a similar Sögäl *mazâr* in the Ferghana Valley, see Nodirbek Abdulahatov and Vahobjon Azimov, *Oltiariq ziyoratgohlari* [The Places of Pilgrimages in Oltiariq] (Toshkent: Sharq, 2005): 54.

18 Sawada Minoru, "A Study of the Current Ordam-Padishah System" *Journal of the History of Sufism* 3 (2001): 100–102.

19 Some details in Rahilä Dawut and Rachel Harris, "Mazar Festivals of the Uyghurs: Music, Islam and the Chinese State" *British Journal of Ethnomusicology* 11, No. 1 (2002): 108, 114–15.

20 As one sign among many, every publication on the Uyghur culture devotes a section to *mazârs*. Interestingly, a journal dealing exclusively on patrimony has been created, called *Shinjang Mädäniyät Yadikarliqliri*. The question of patrimony should be analyzed more broadly, however, at the scale of the whole country. See Jocelyne Fresnais, *La protection du patrimoine en République populaire de Chine, 1949–1999* (Paris : Editions du CNRS, 2001); and Liang Zhang, *La naissance du concept de patrimoine en Chine, XIXe–XXe siècles* (Paris : Editions Recherches/ Ipraus, 2003).

21 Rahilä Dawut, "Shrine Pilgrimage and Sustainable Tourism among the Uyghurs: Central Asian Ritual Traditions in the Context of China's Development Policies," in *Situating the Uyghurs between China and Central Asia*, ed. I Bellér-Hann, M.Ch. Cesàro, R.A. Harris, and J. Smith Finley, 155–57 (Aldershot: Ashgate, 2007). On the tourism industry in Xinjiang, see Stanley W. Toops, "The Tourism and Handicraft Industries in Xinjiang: Development and Ethnicity in a Minority Periphery," Ph.D. Dissertation, University of Washington, 1990: 95–130.

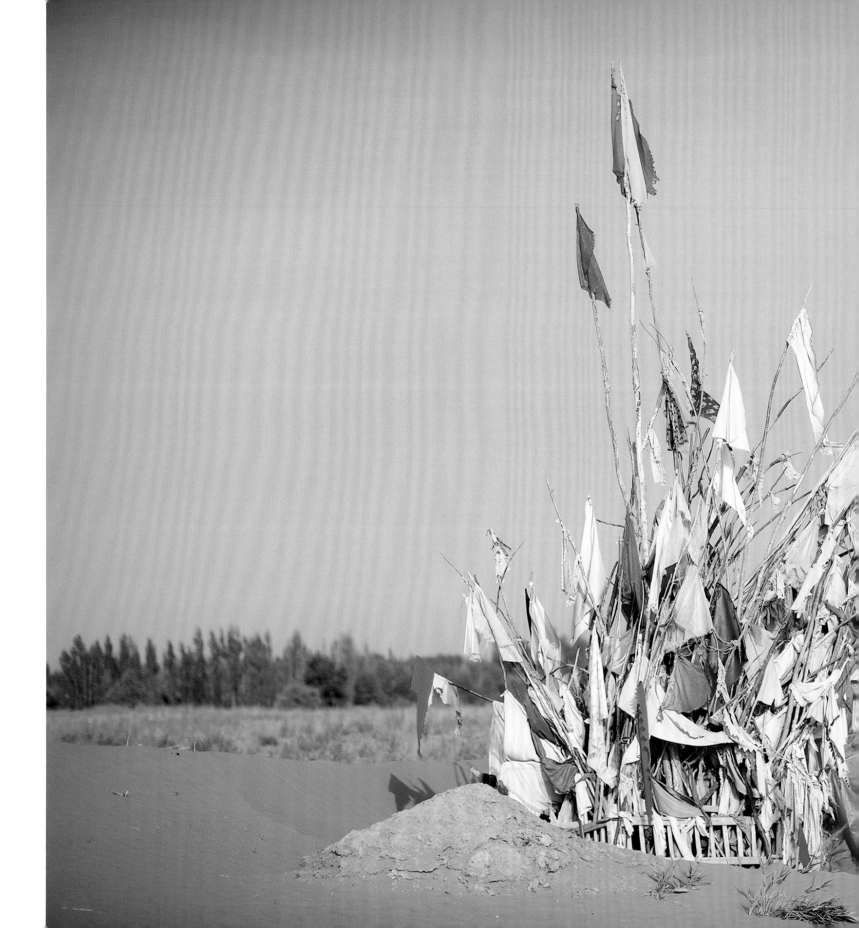

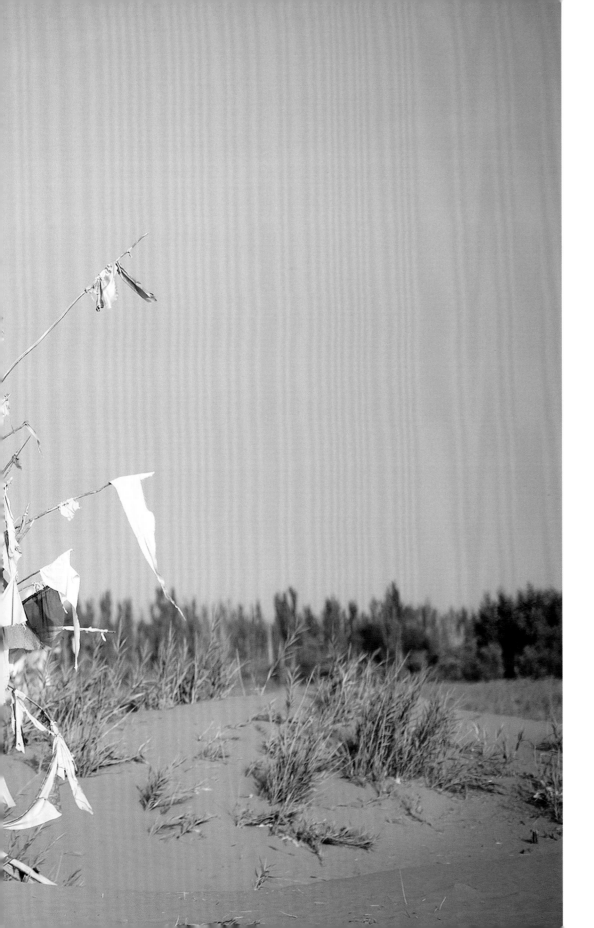

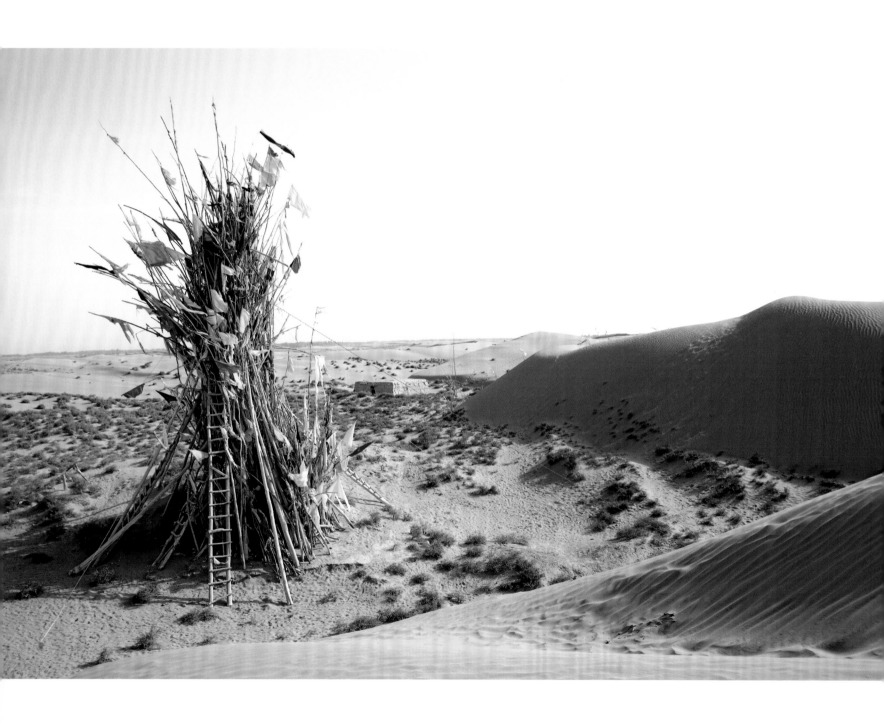

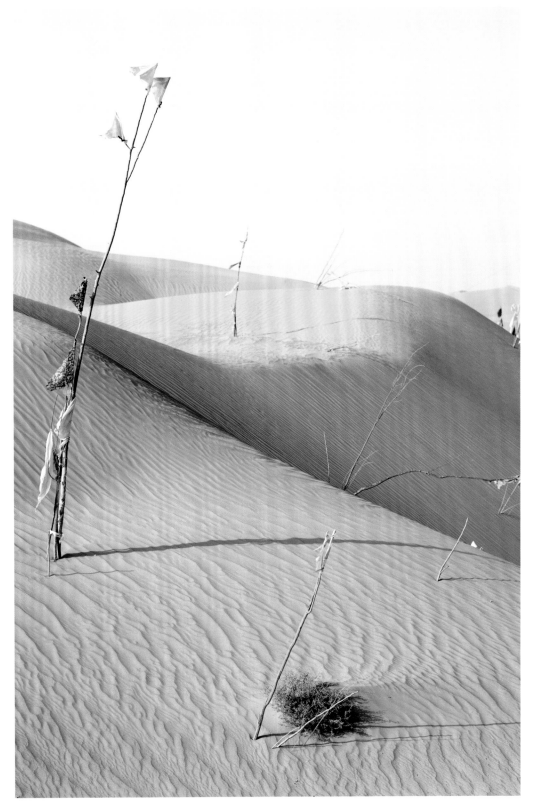

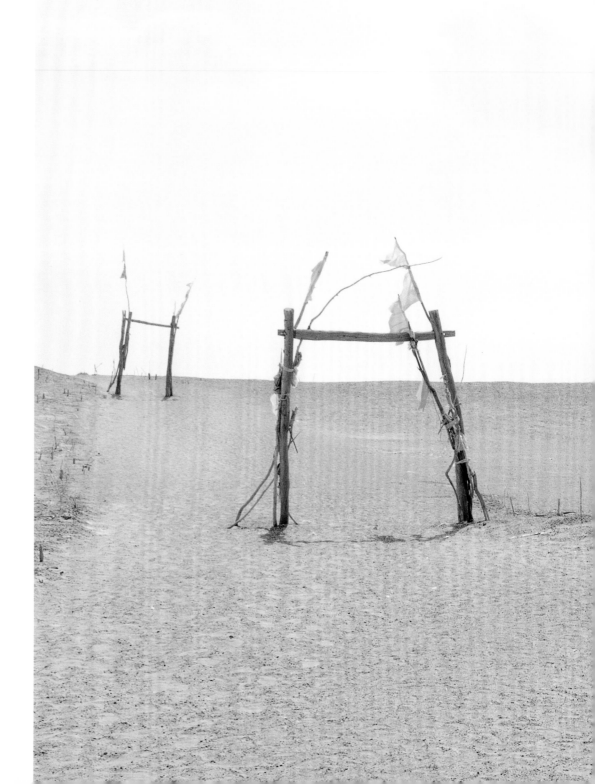

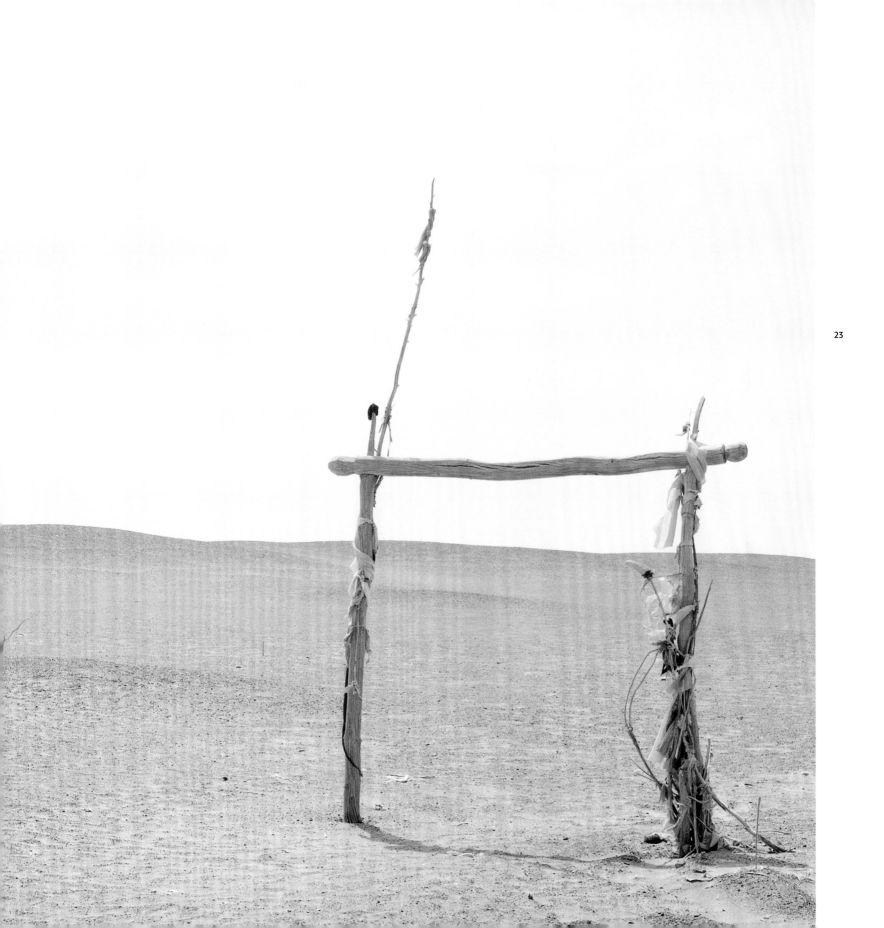

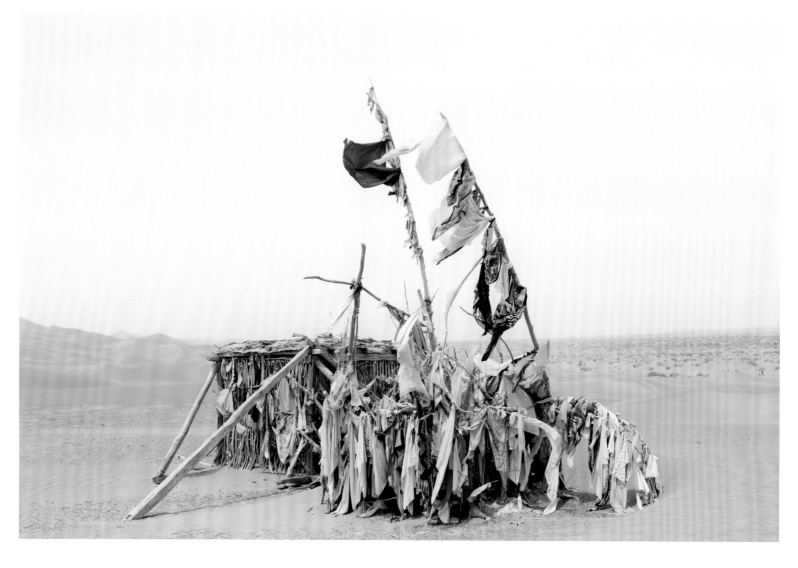

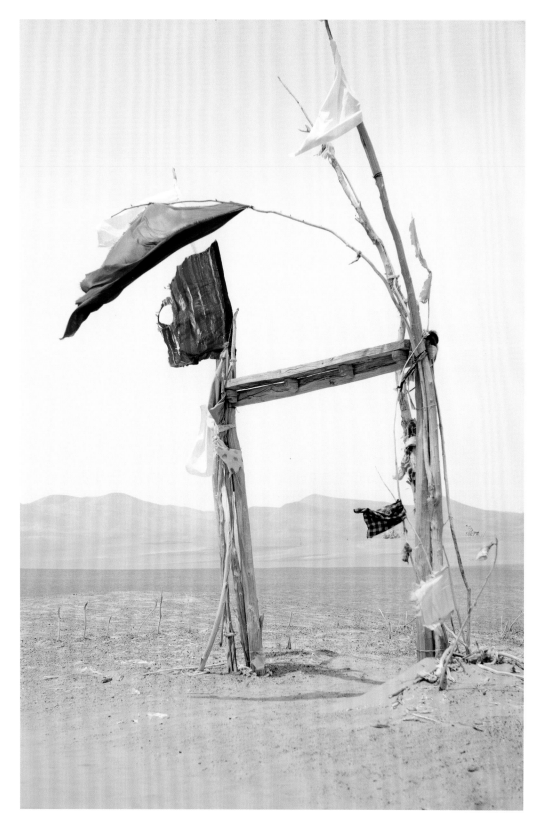

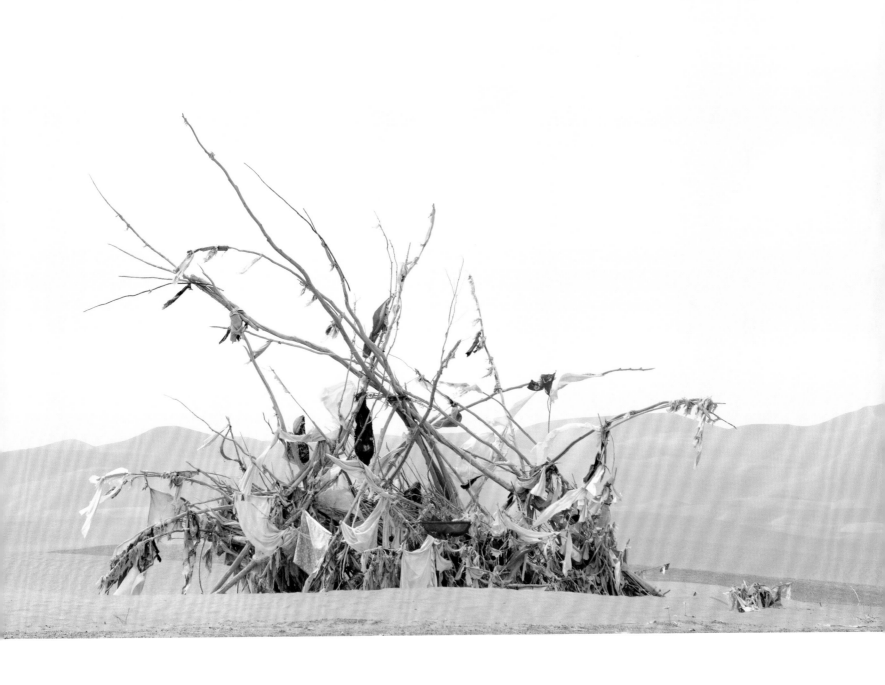

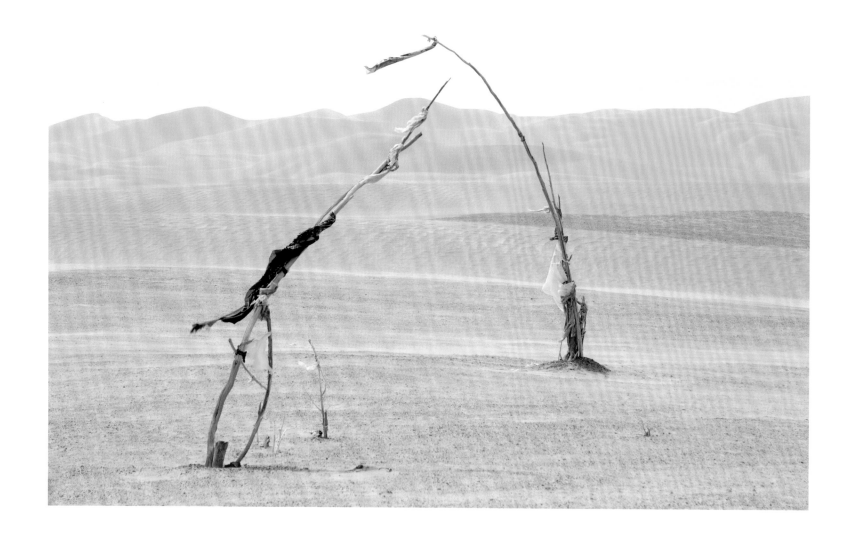

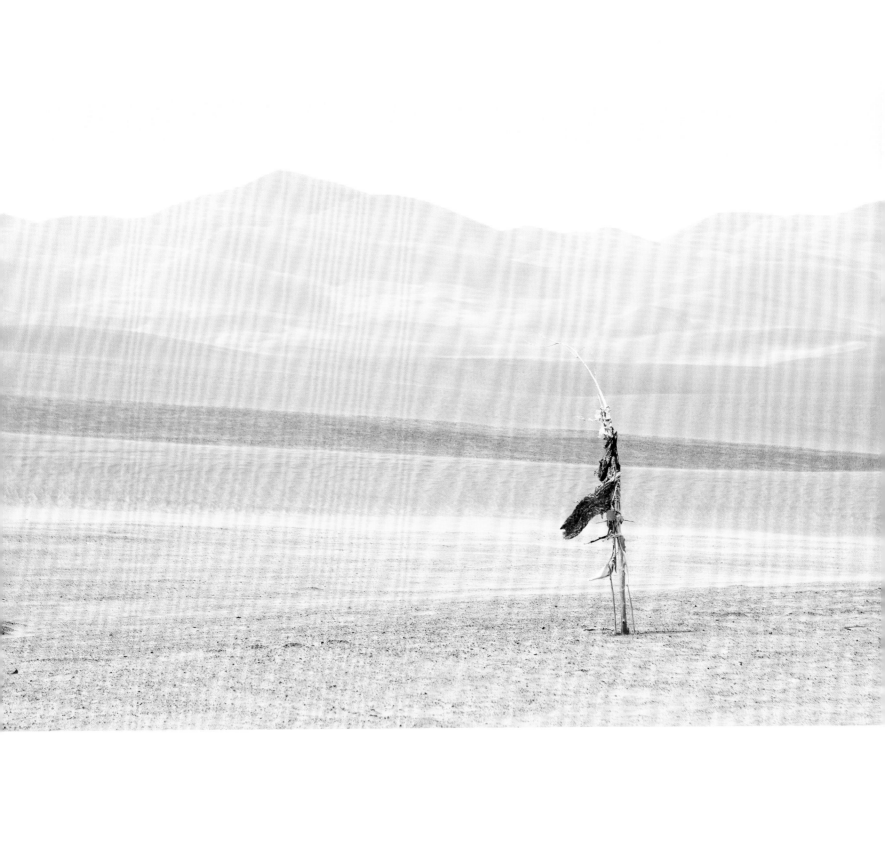

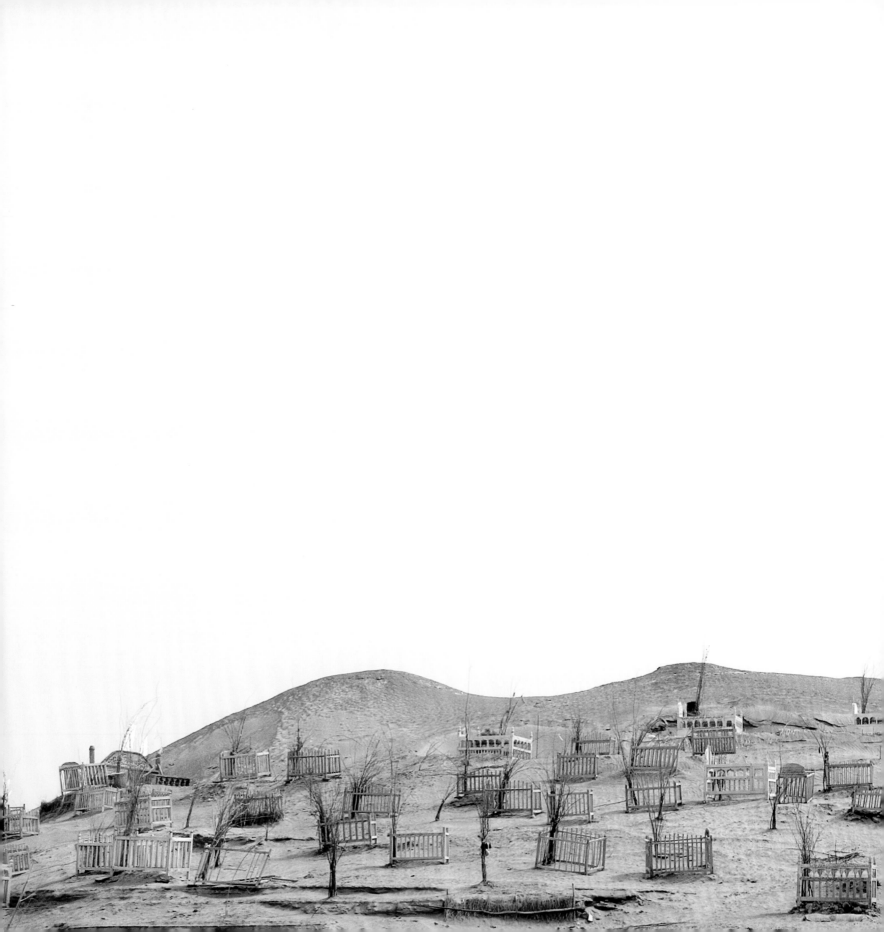

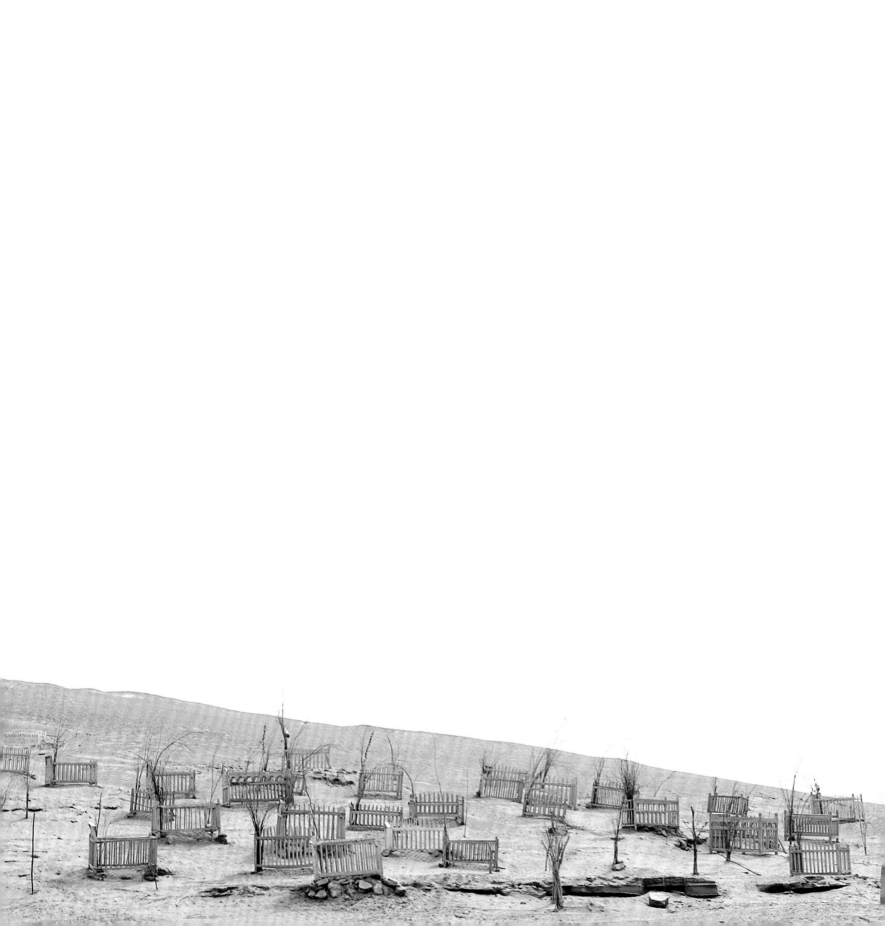

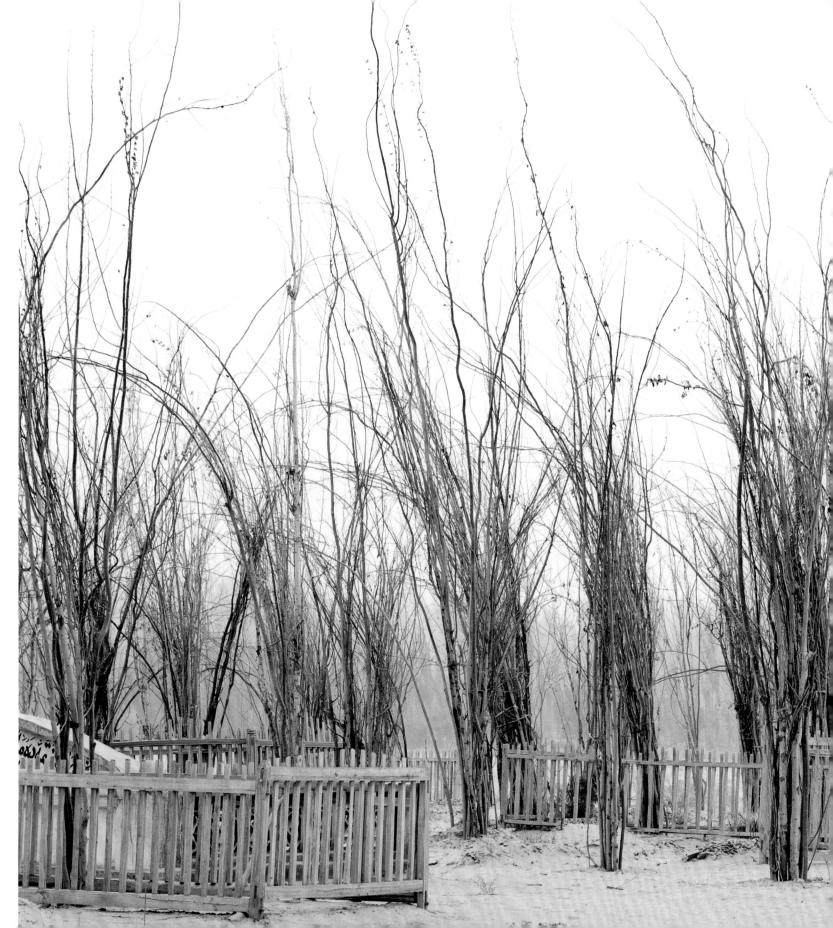

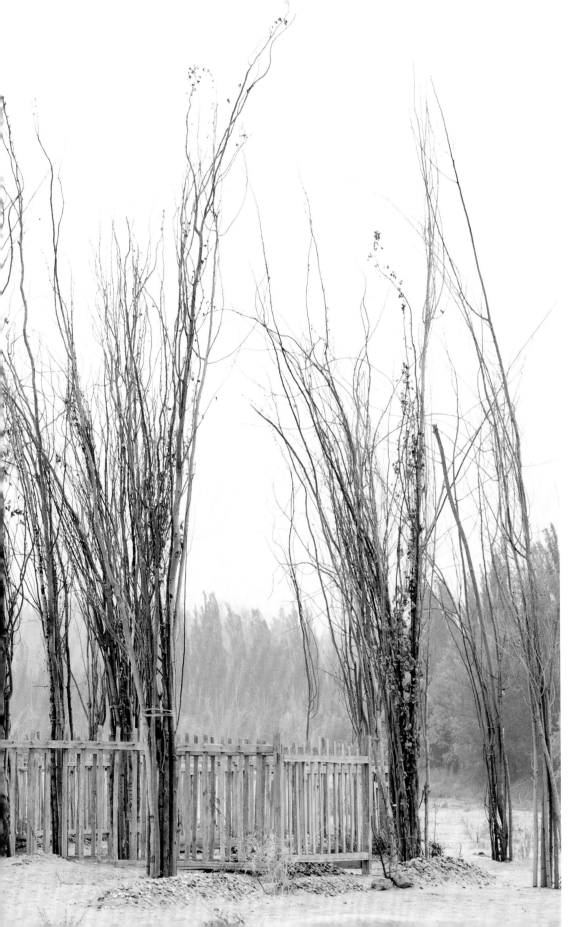

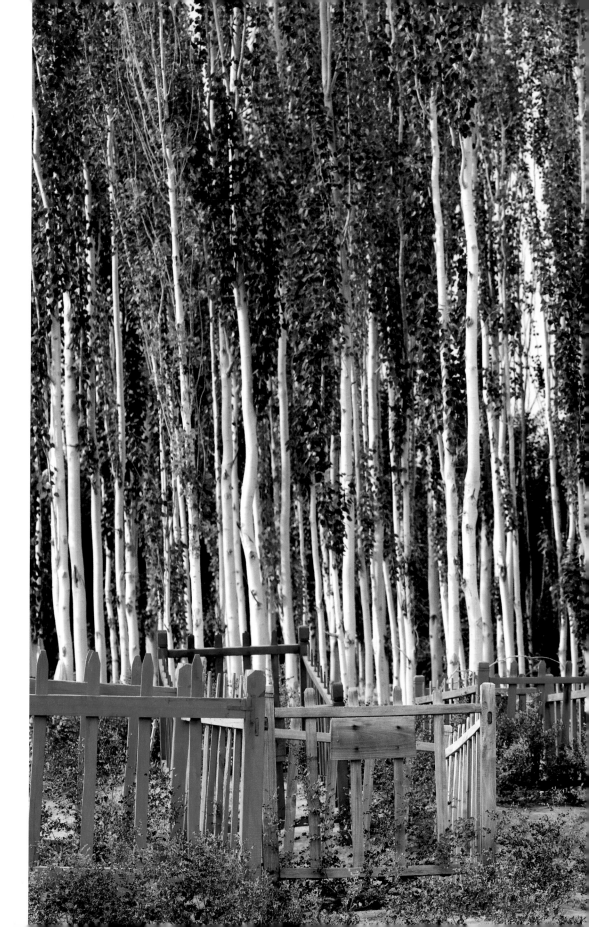

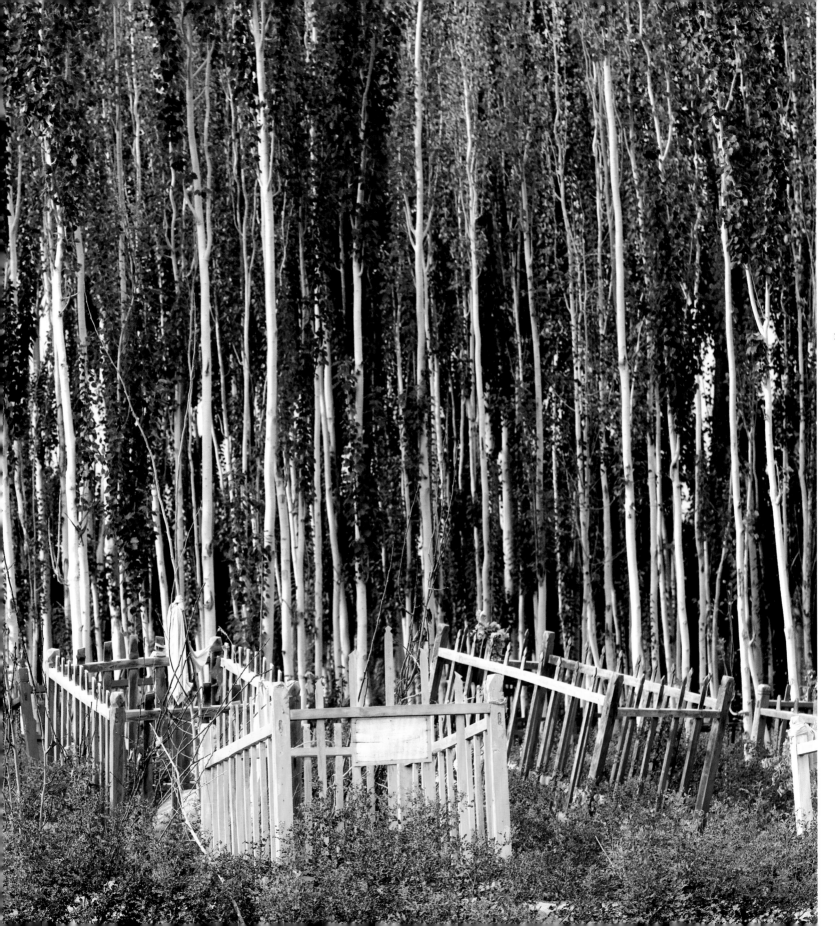

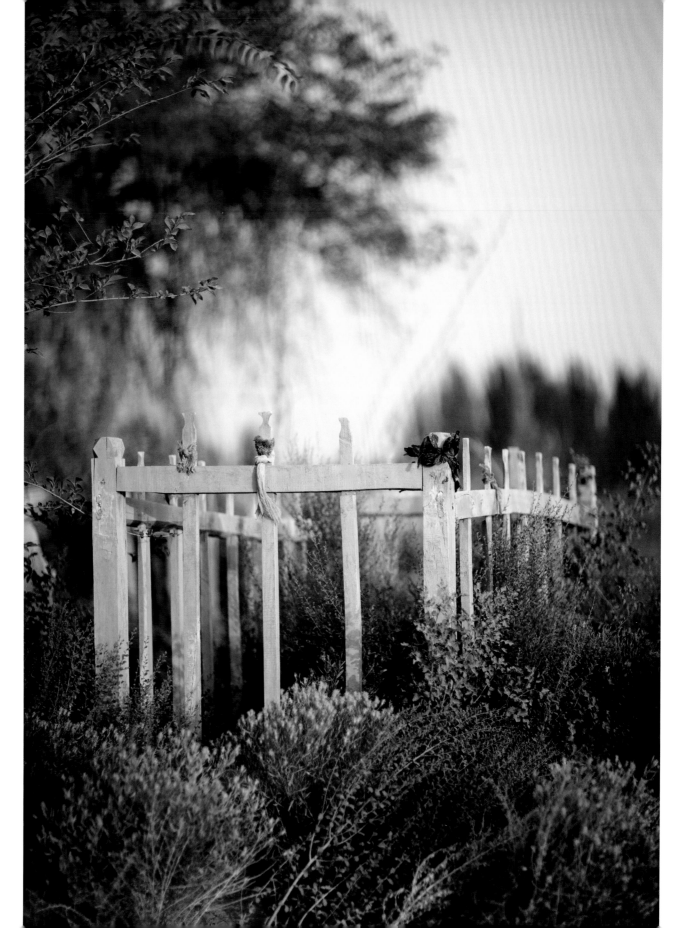

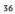

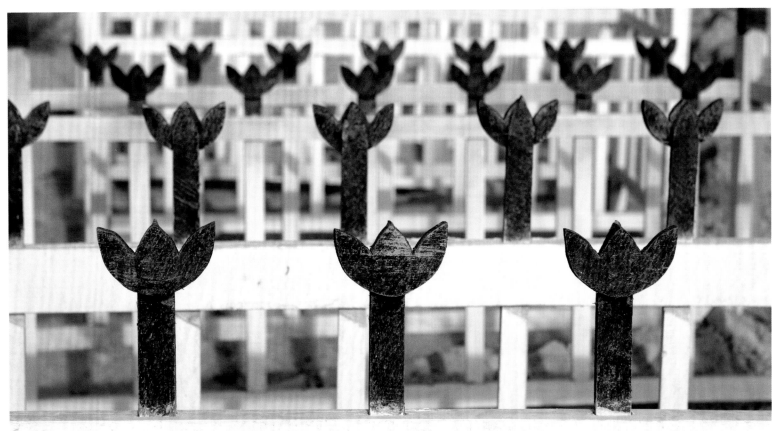

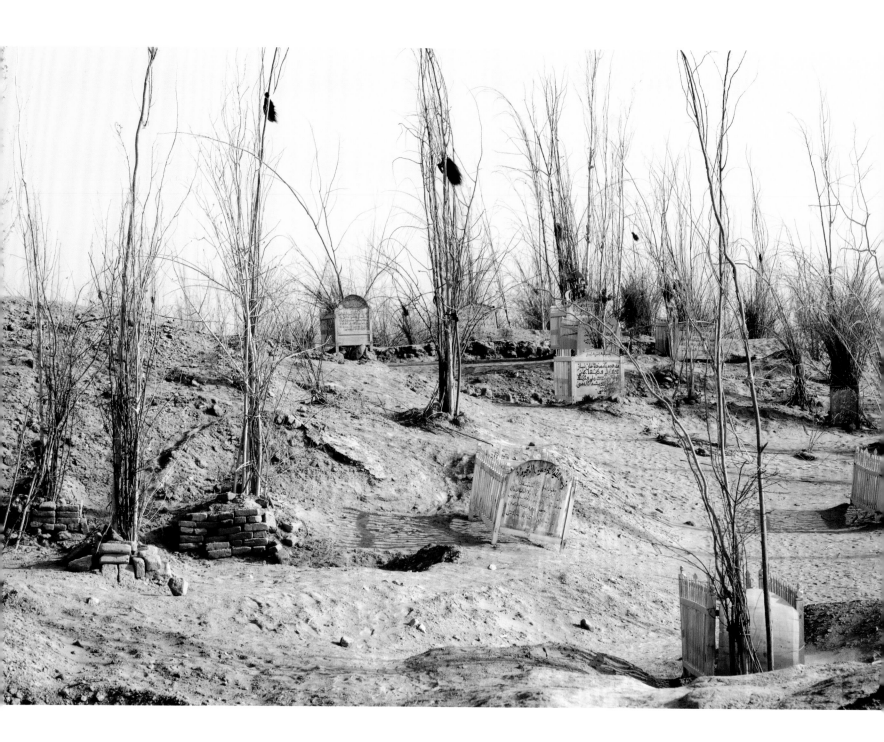

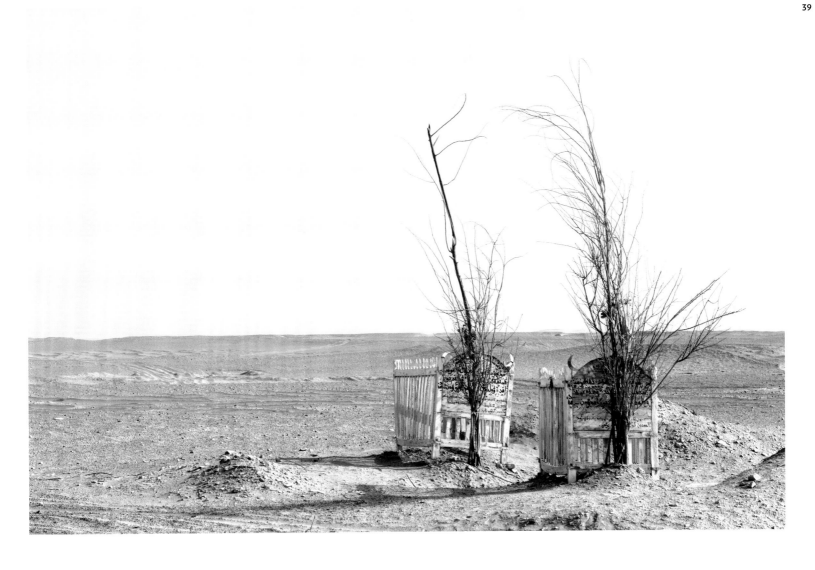

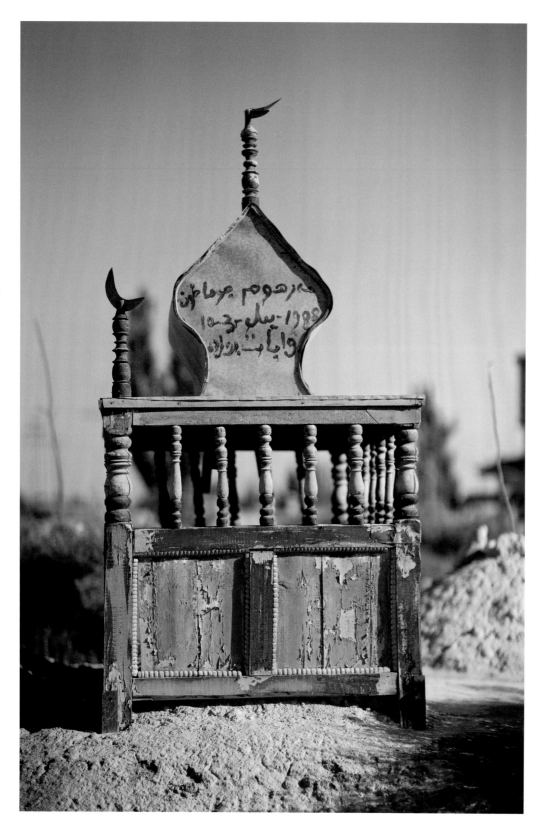

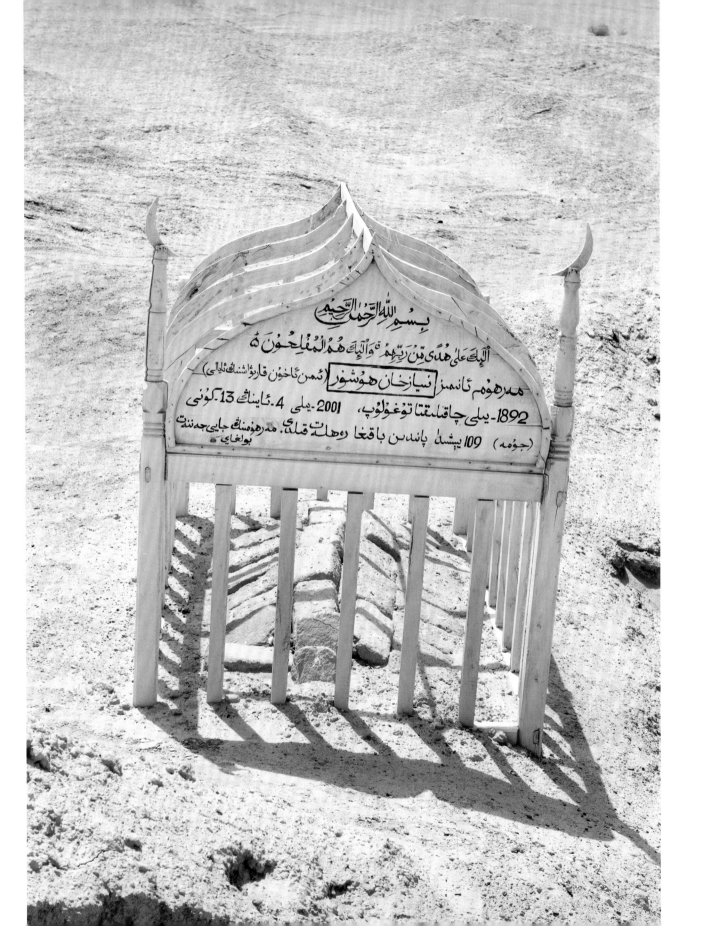

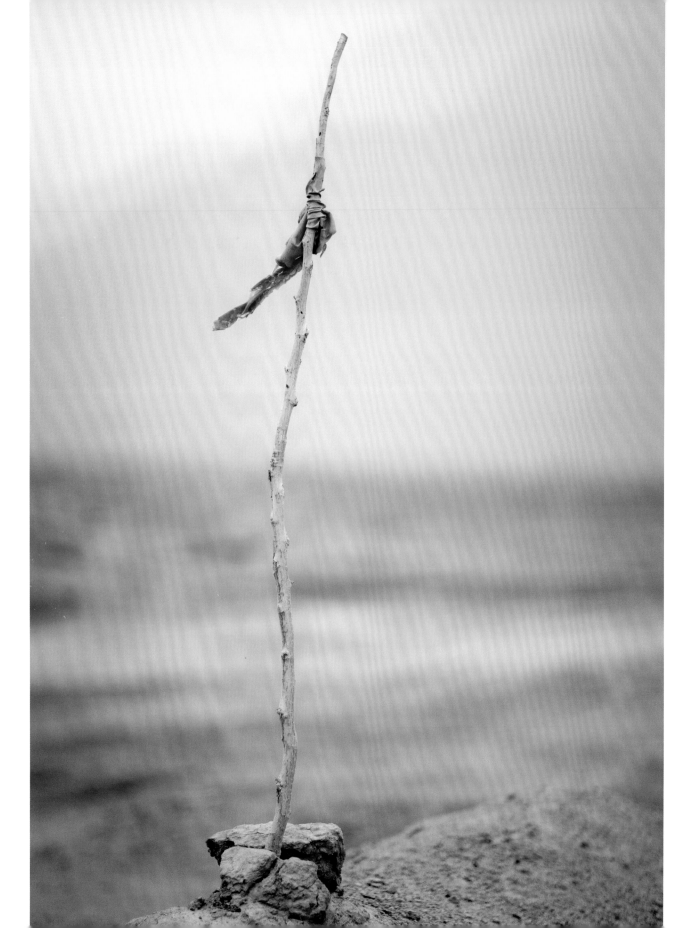

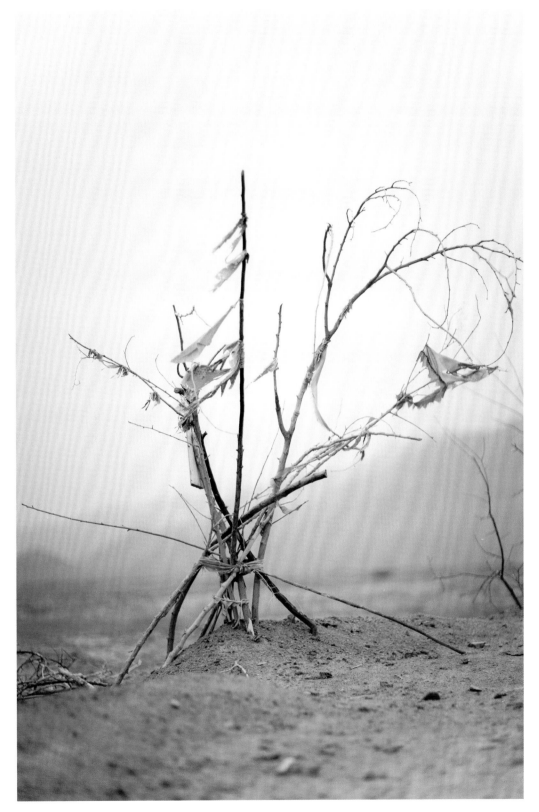

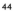

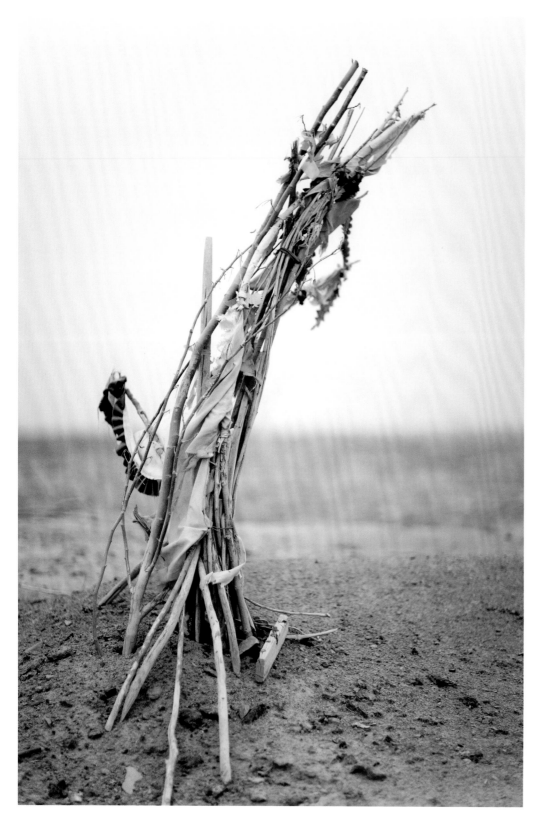

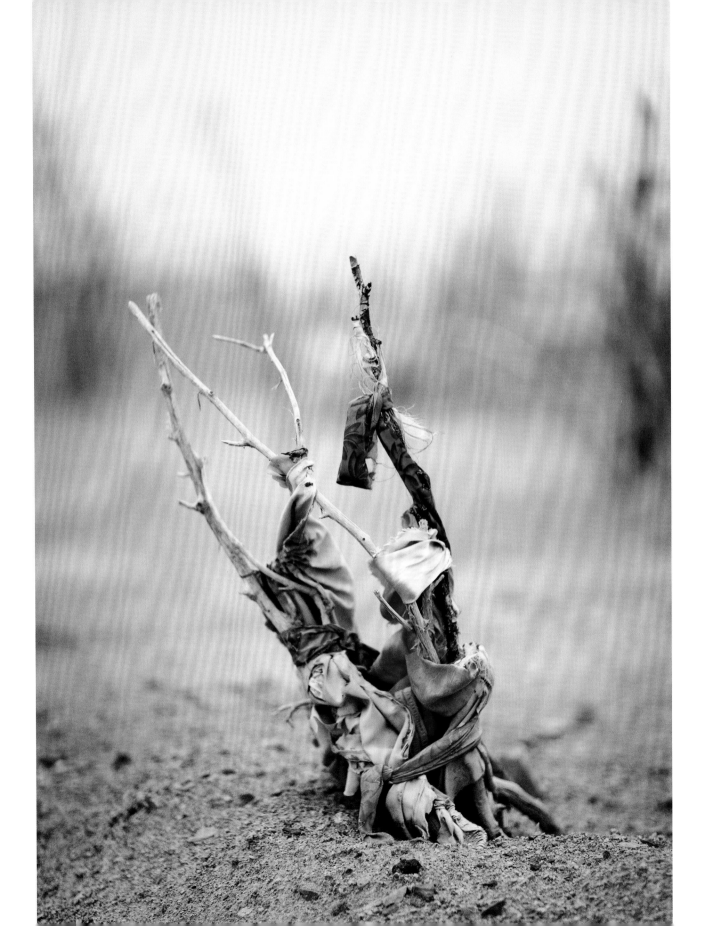

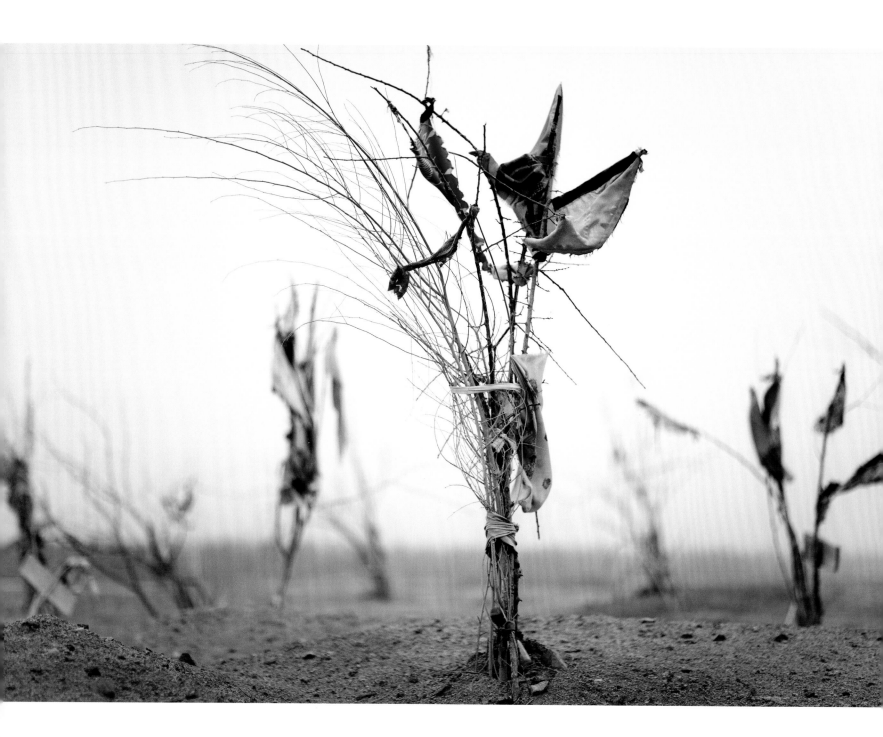

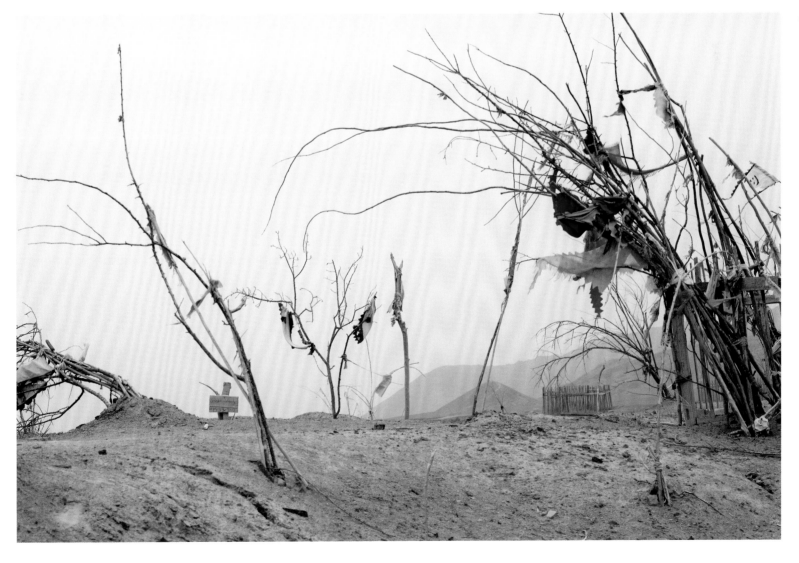

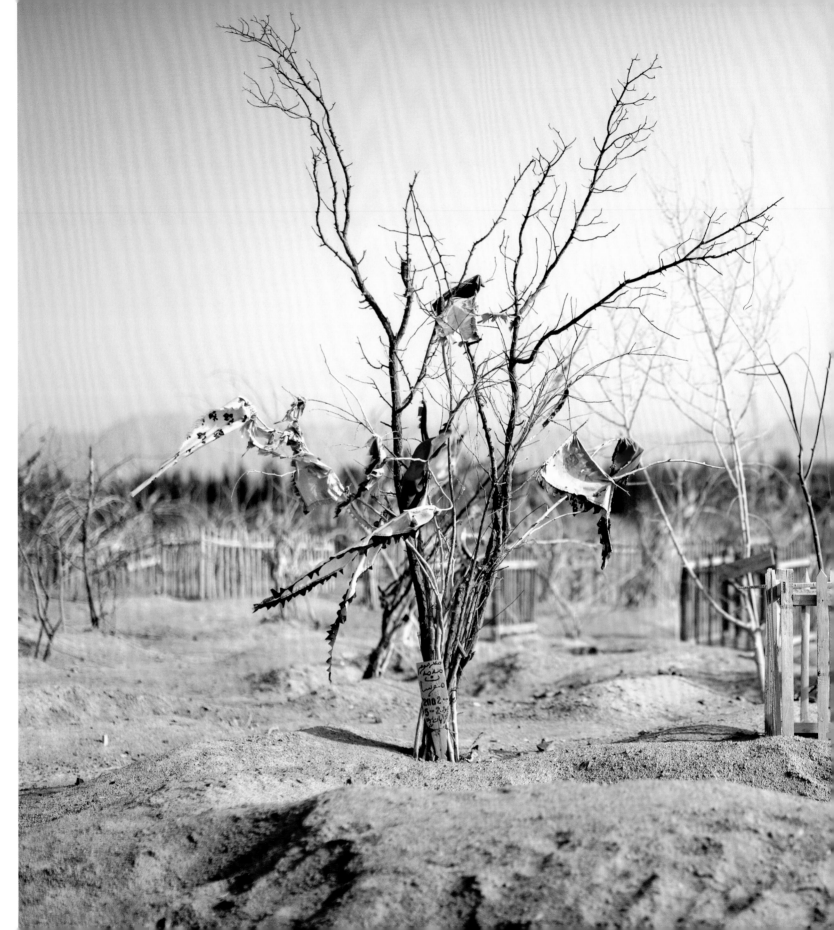

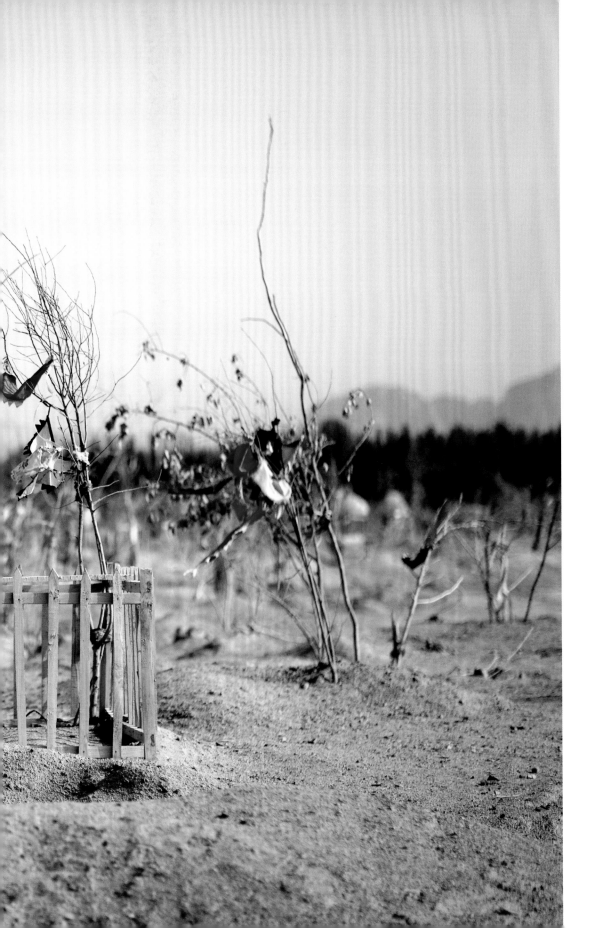

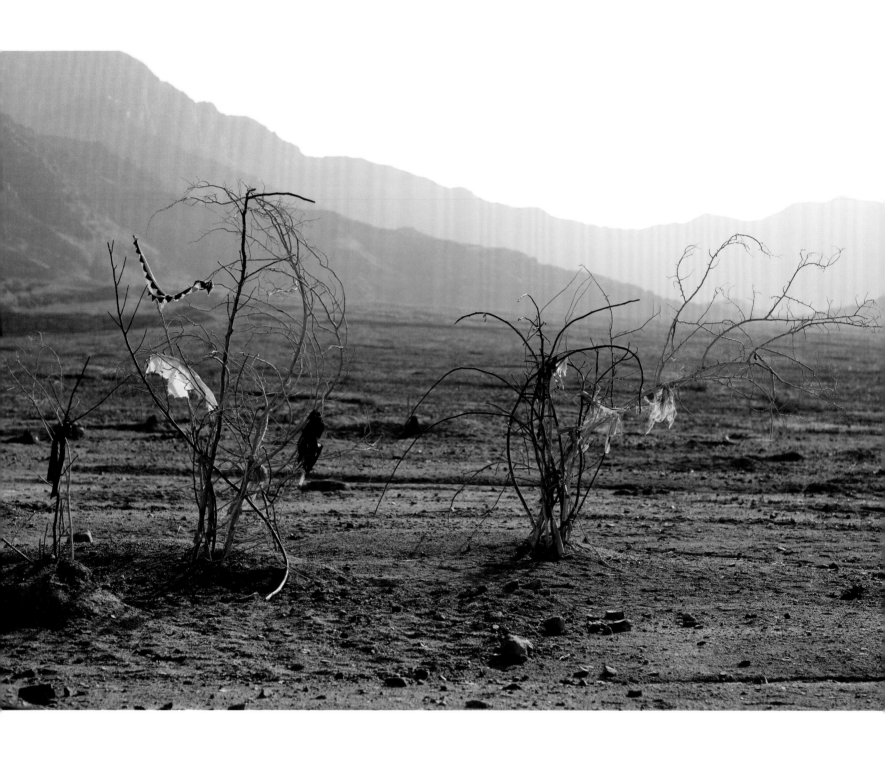

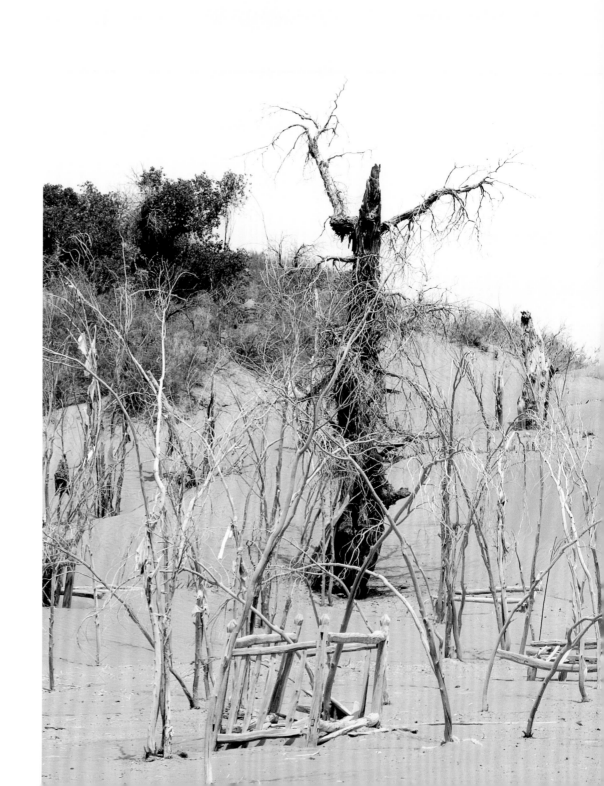

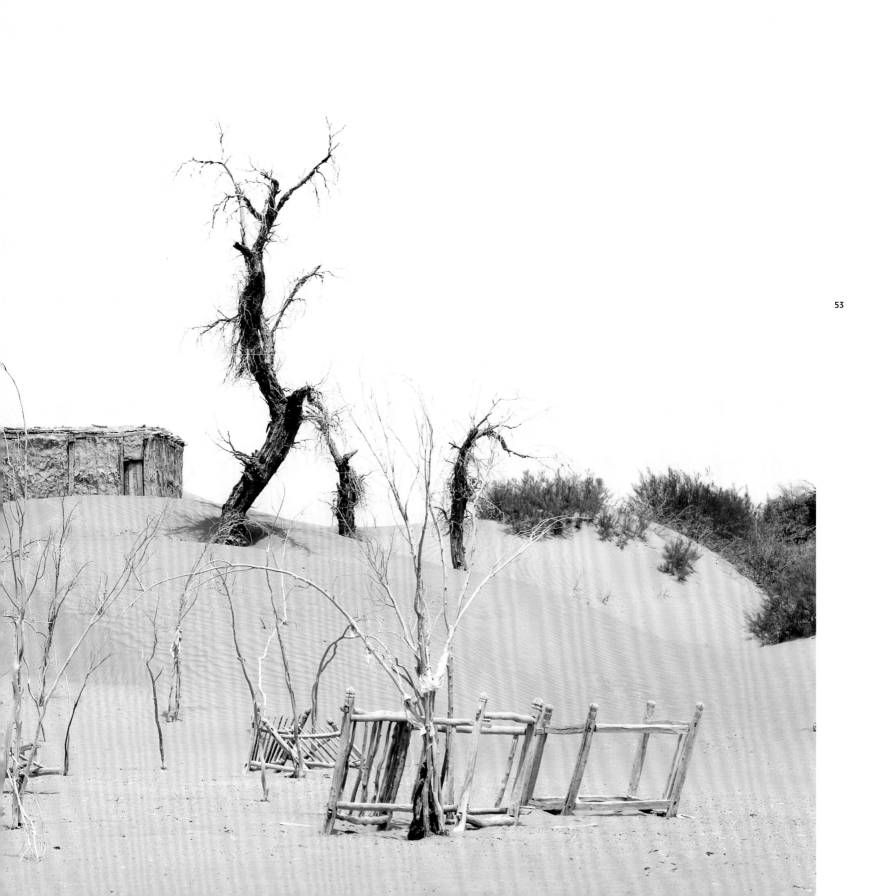

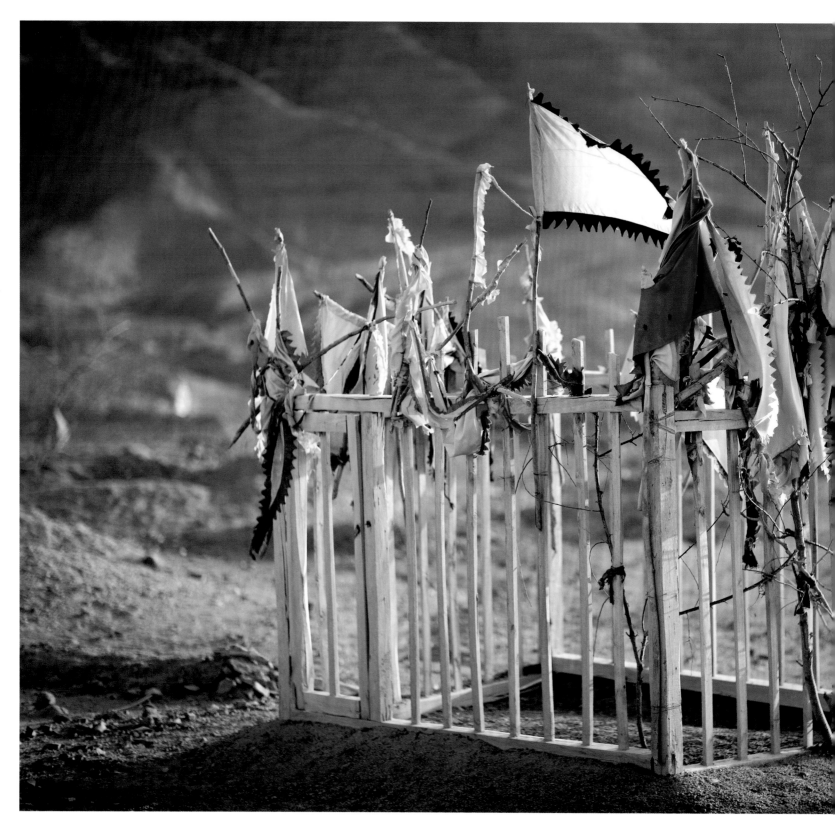

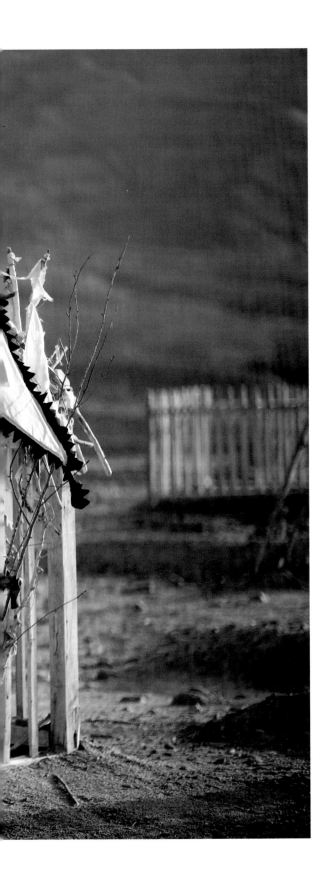

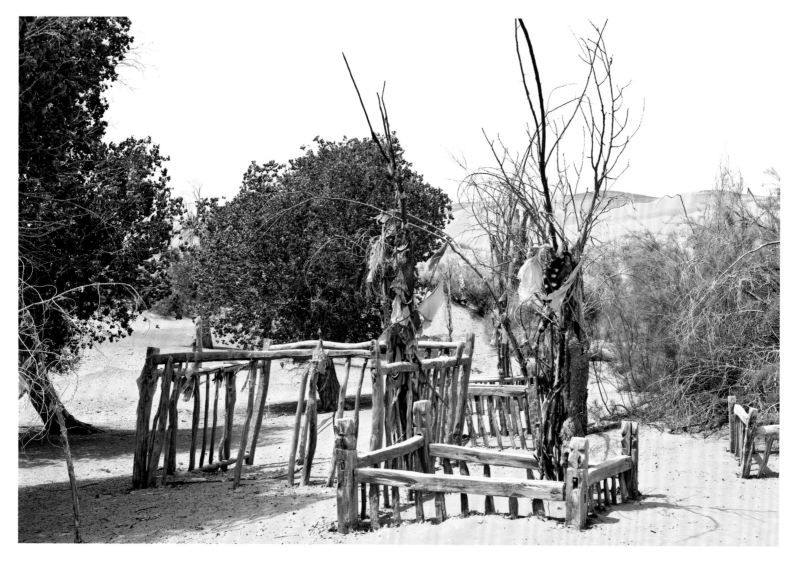

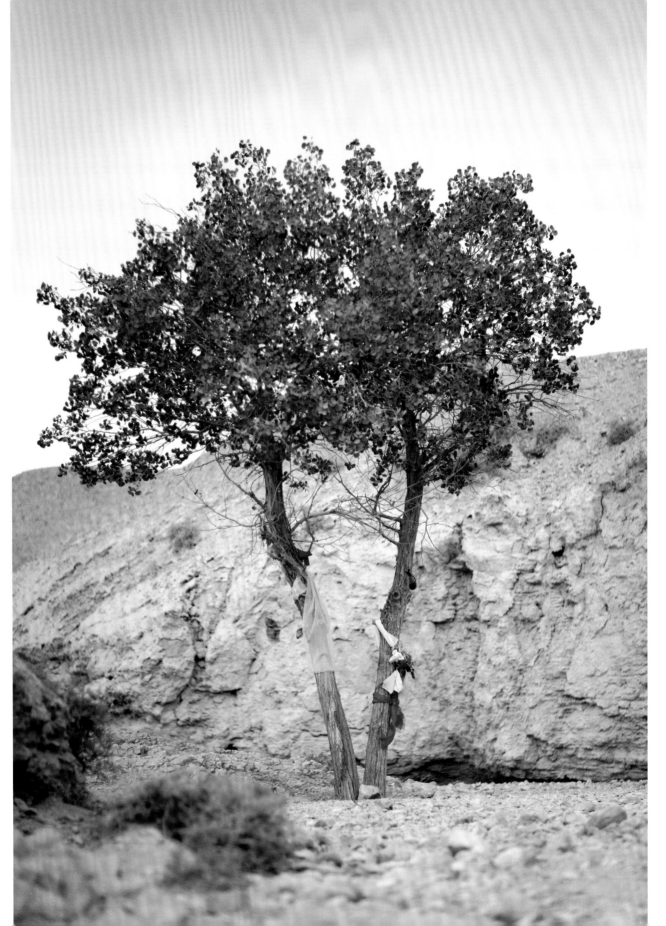

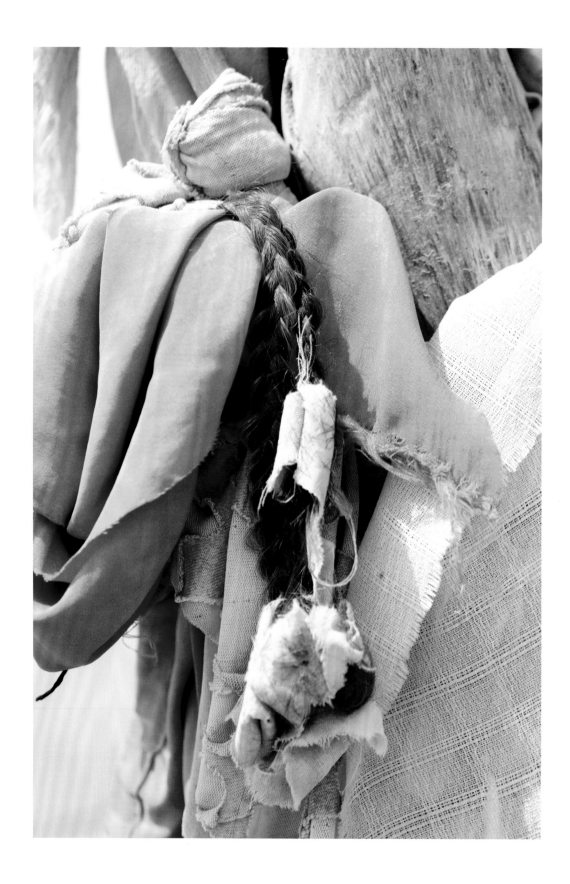

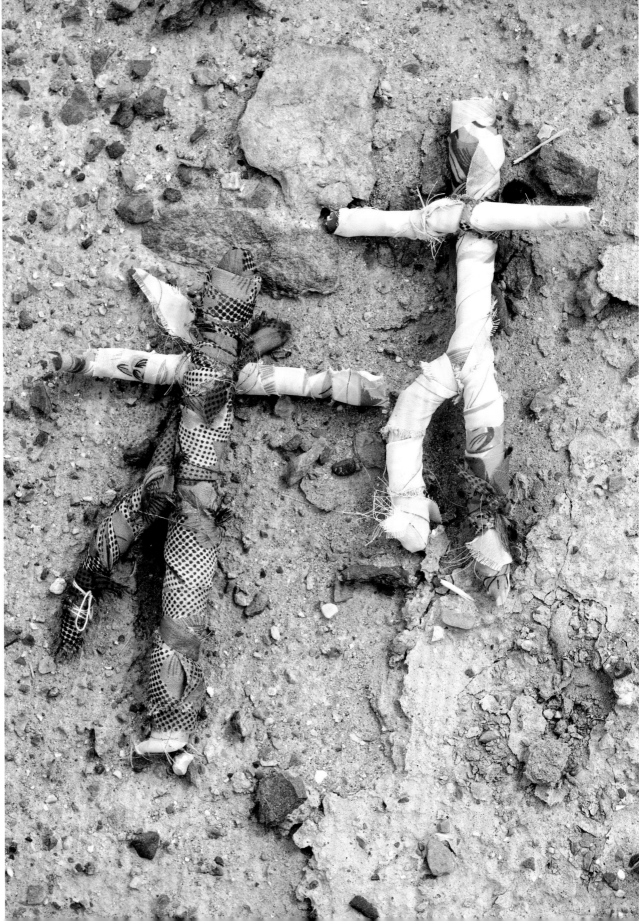

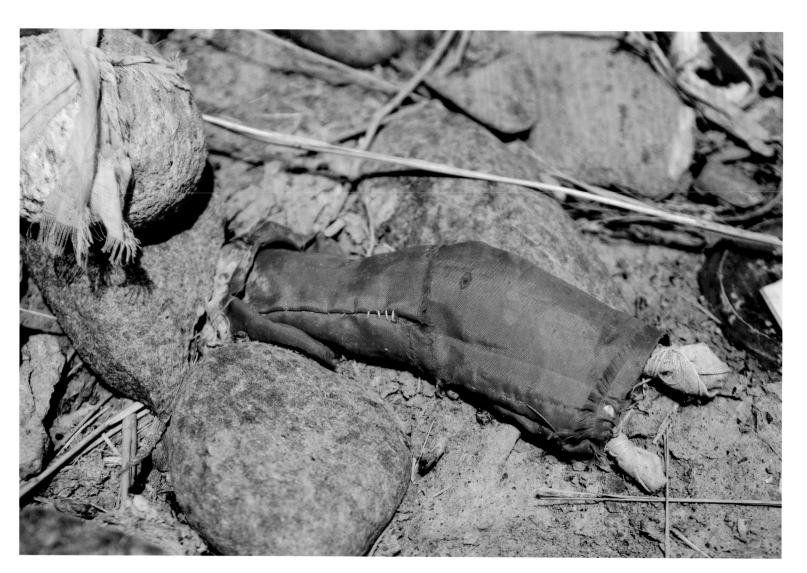

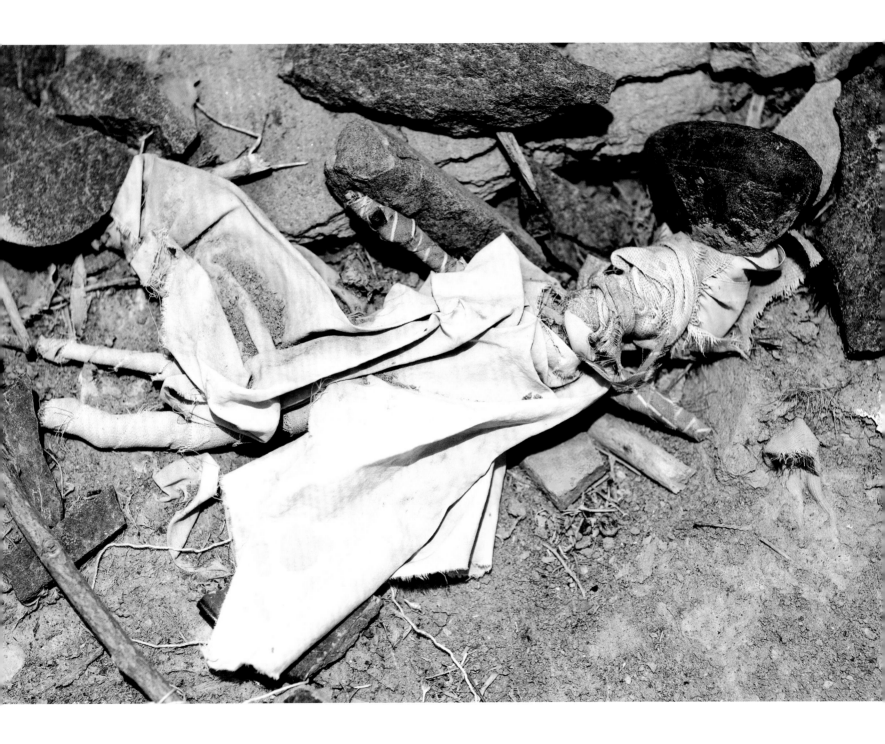

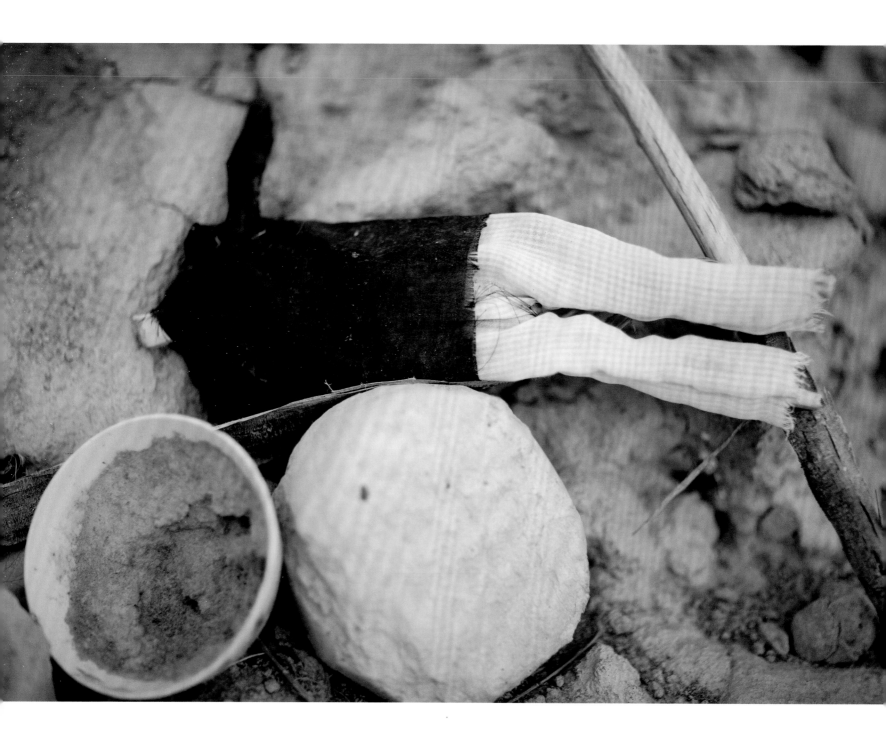

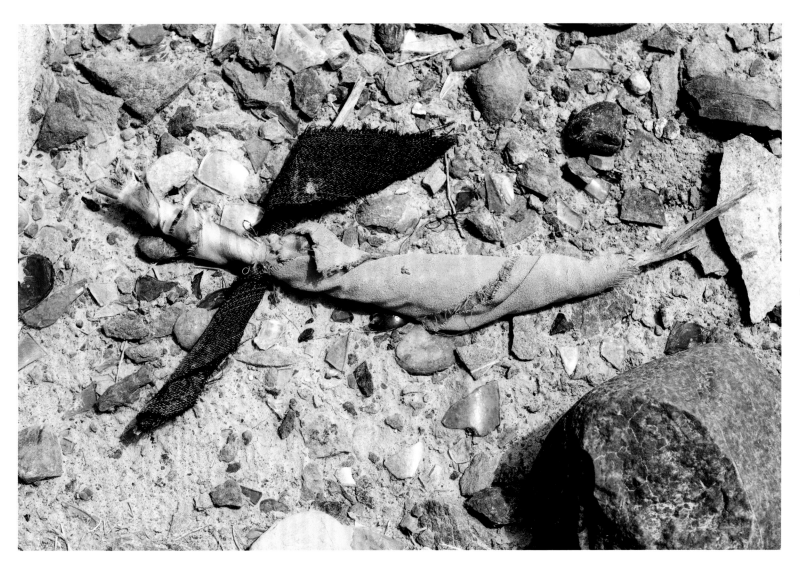

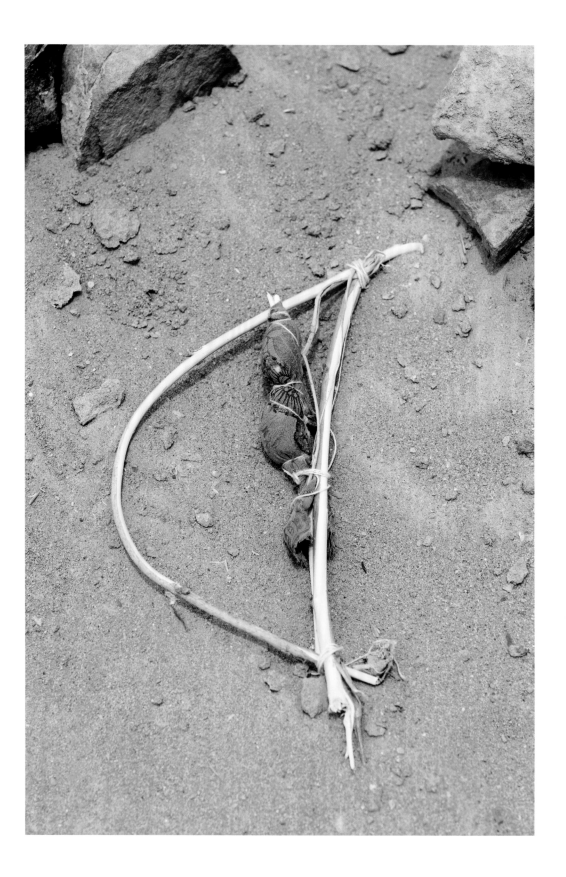

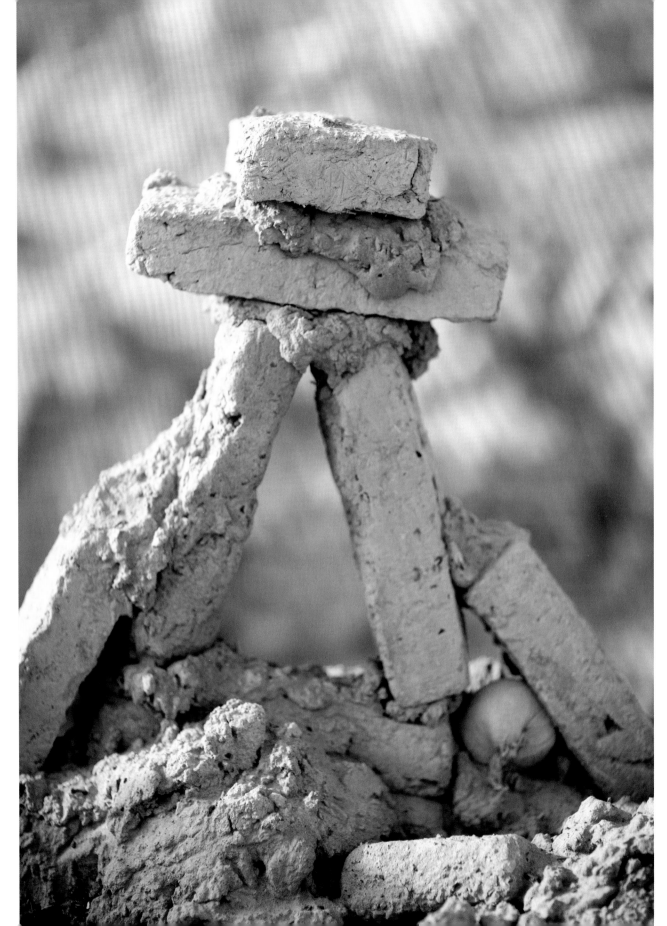

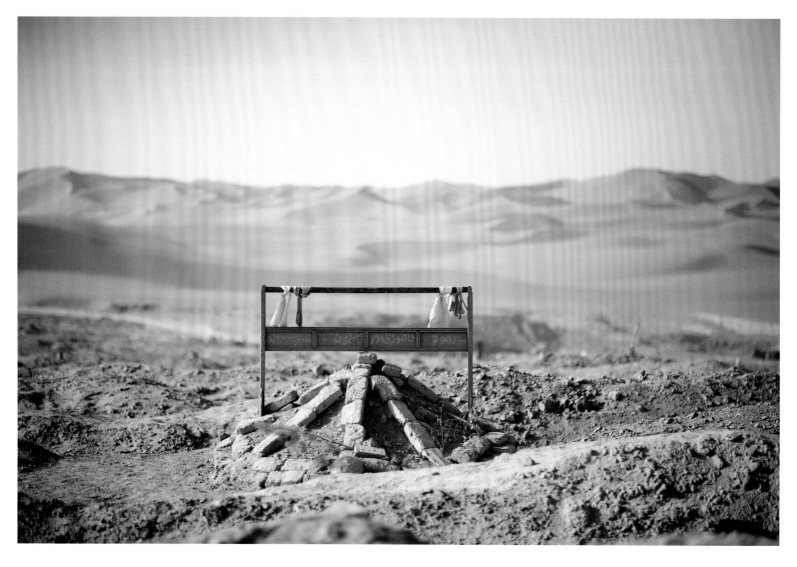

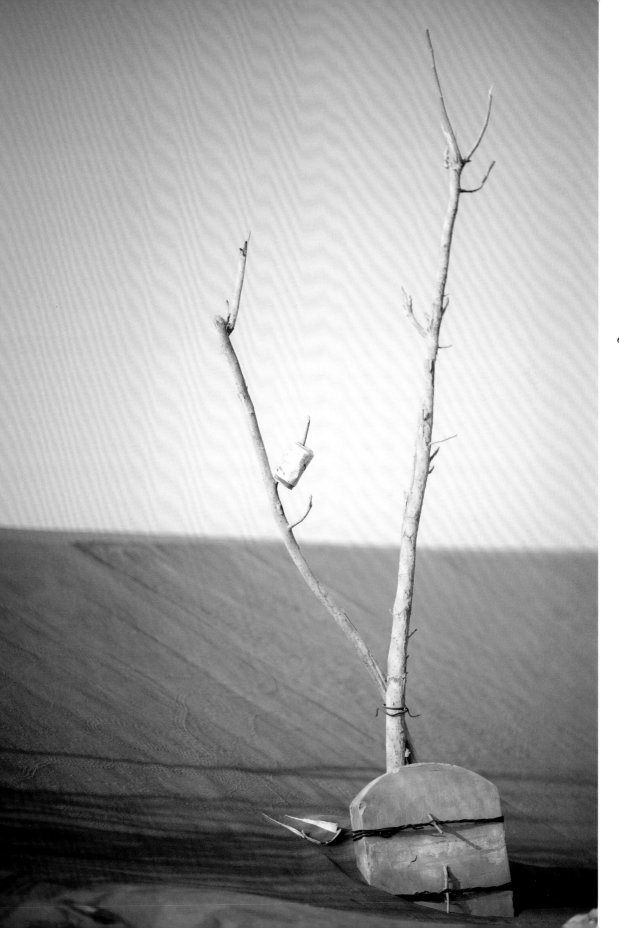

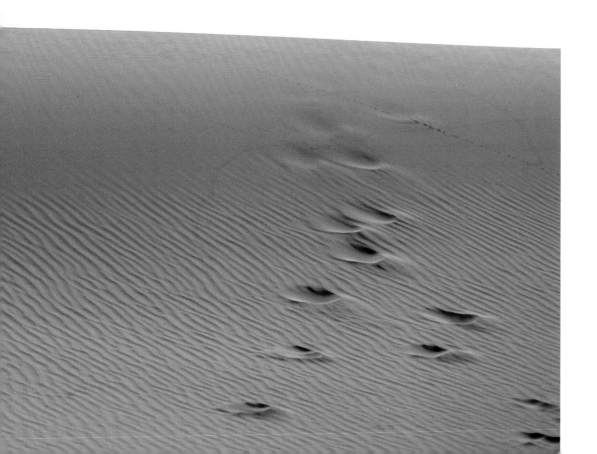

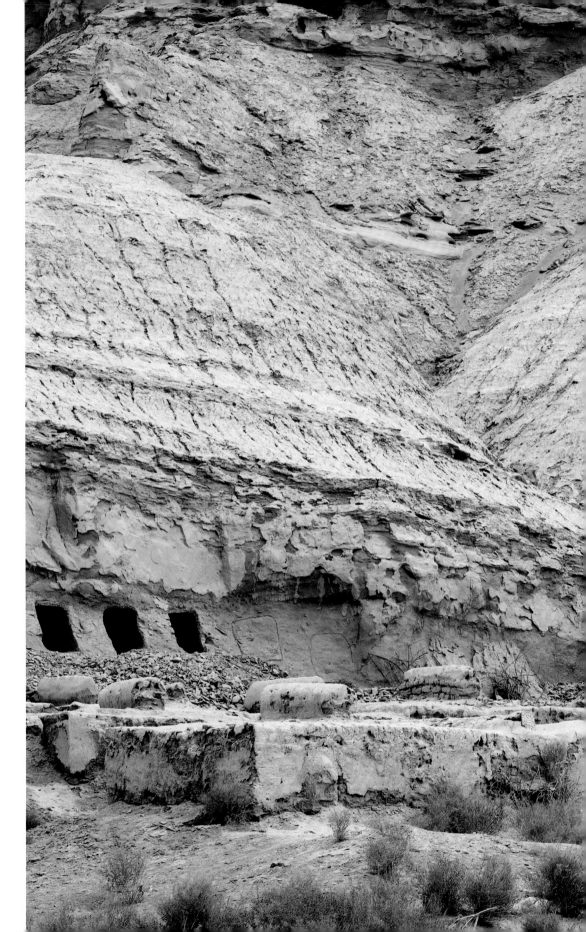

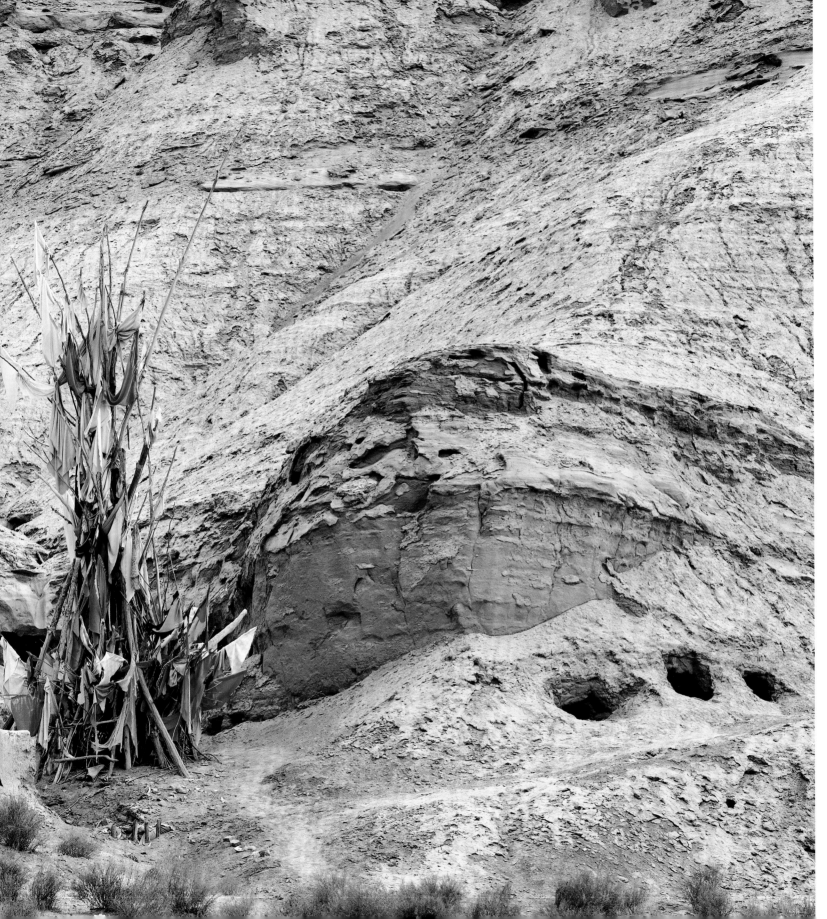

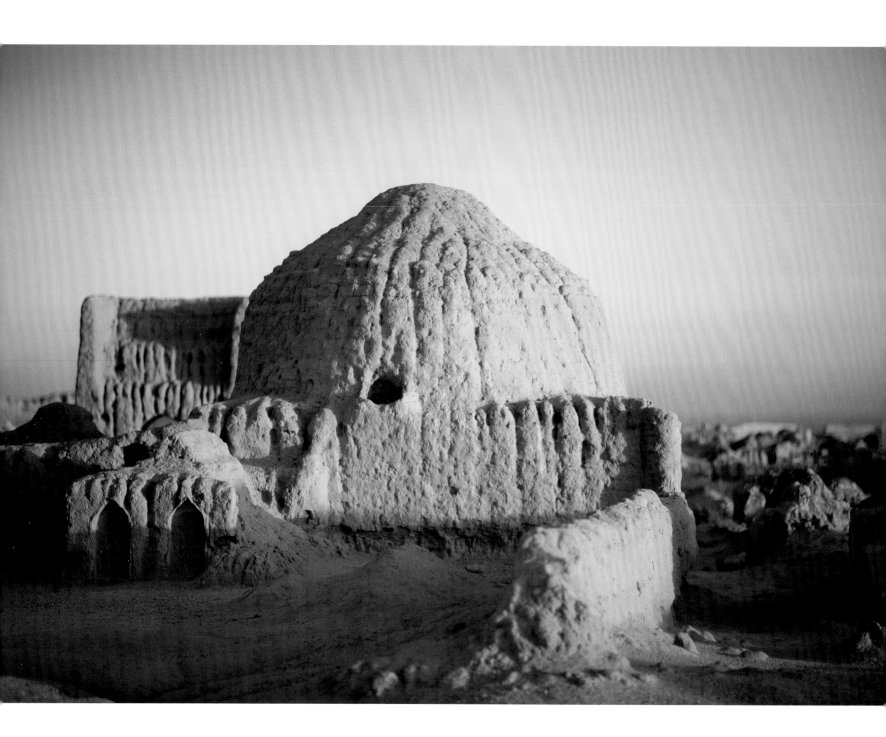

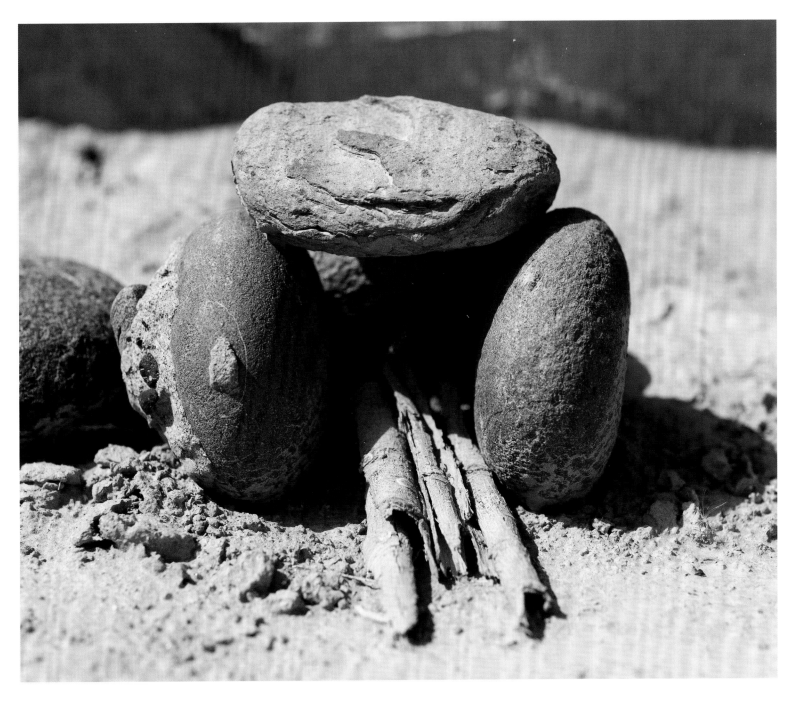

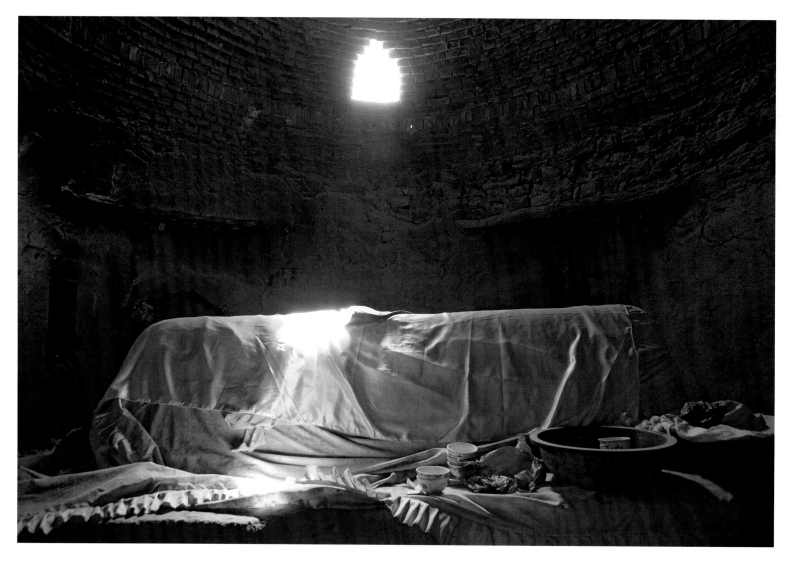

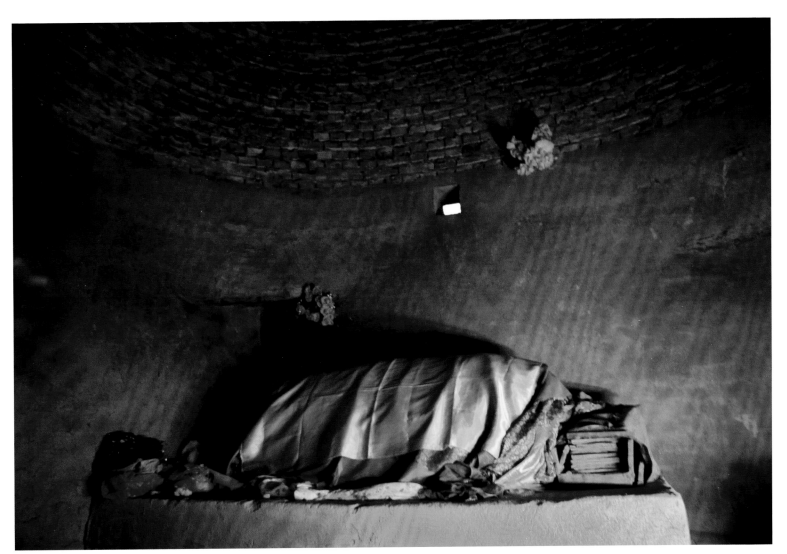

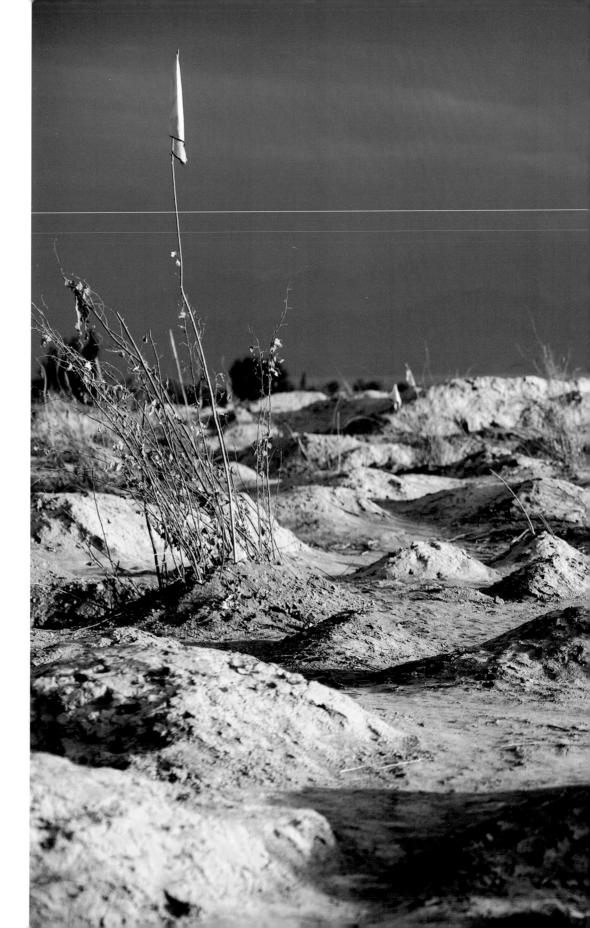

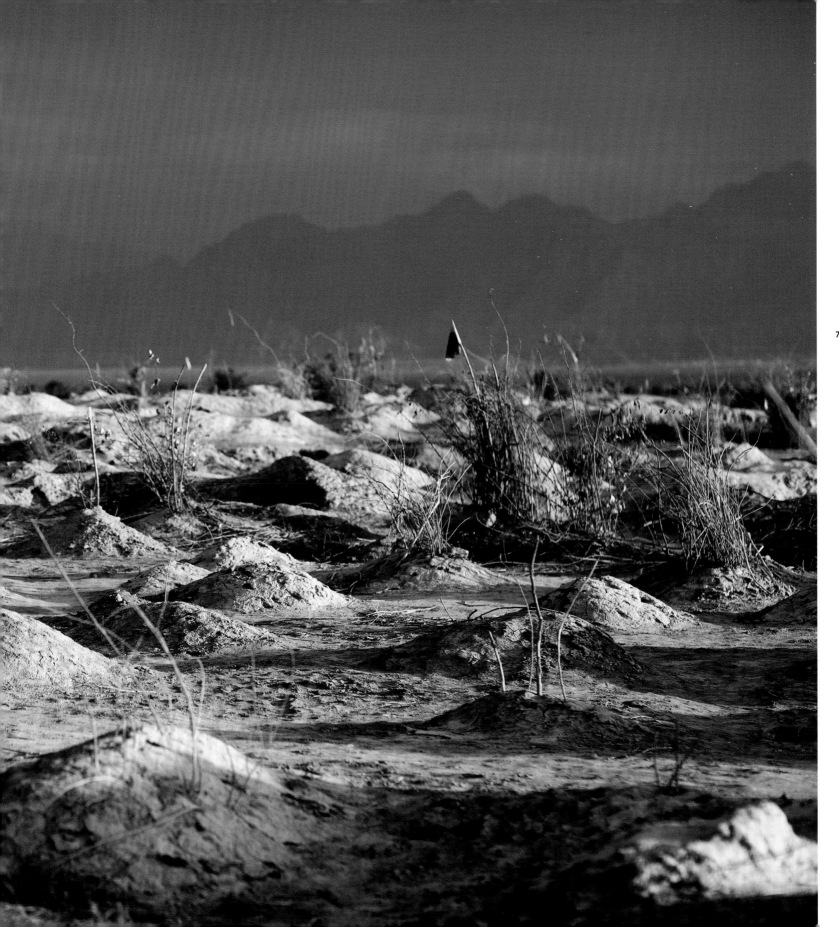

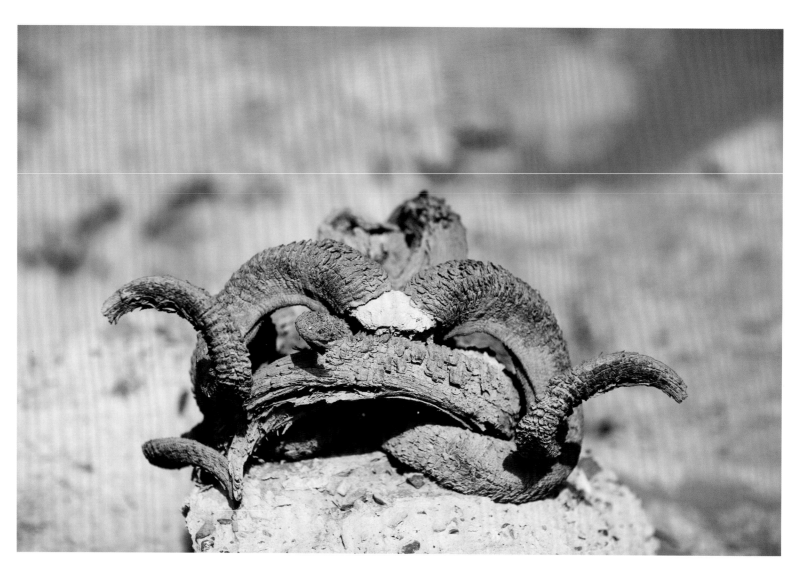

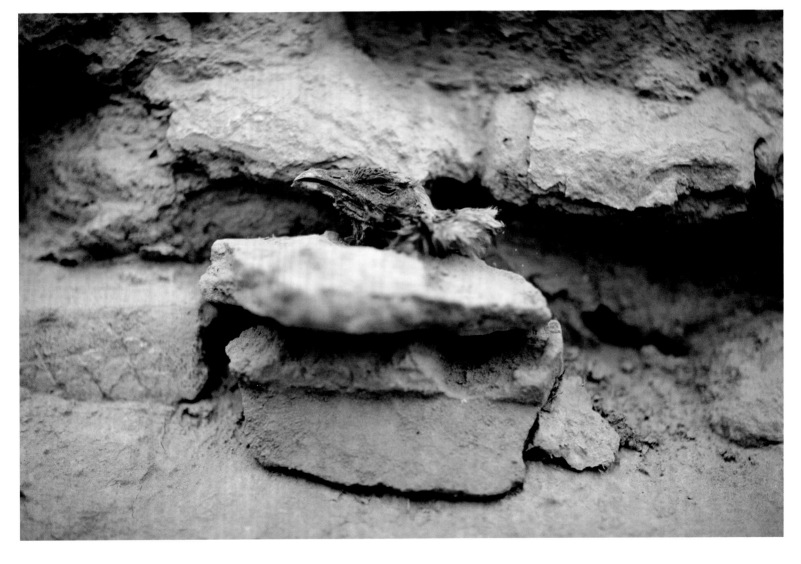

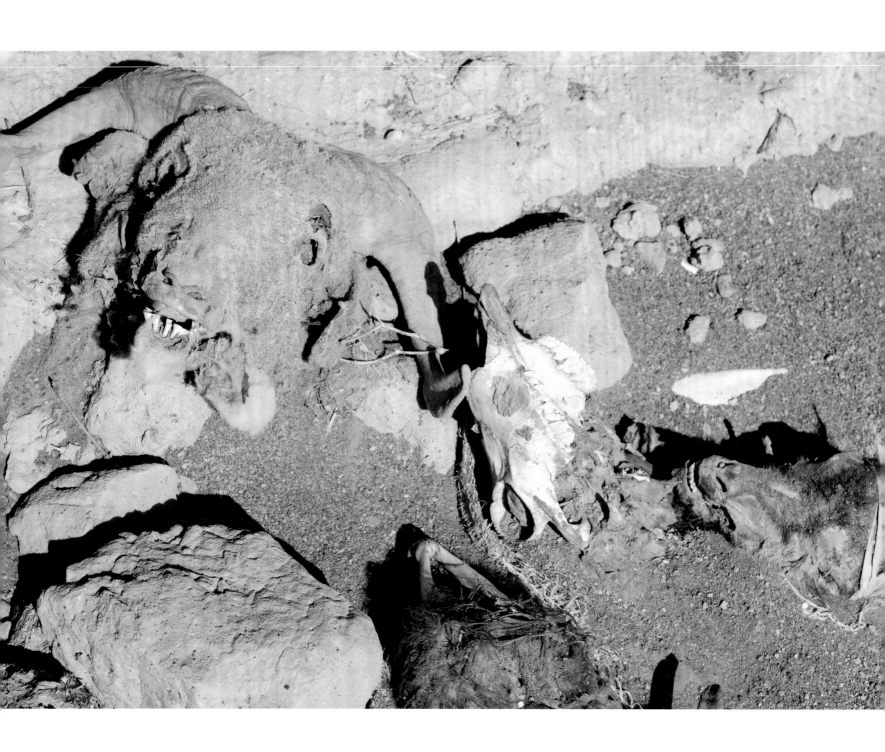

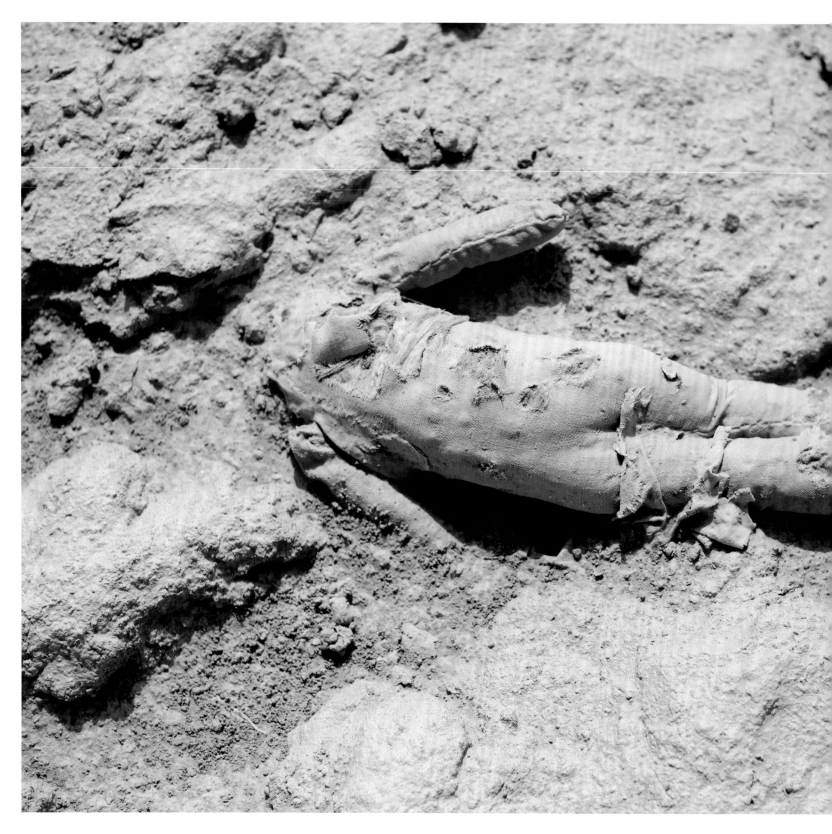

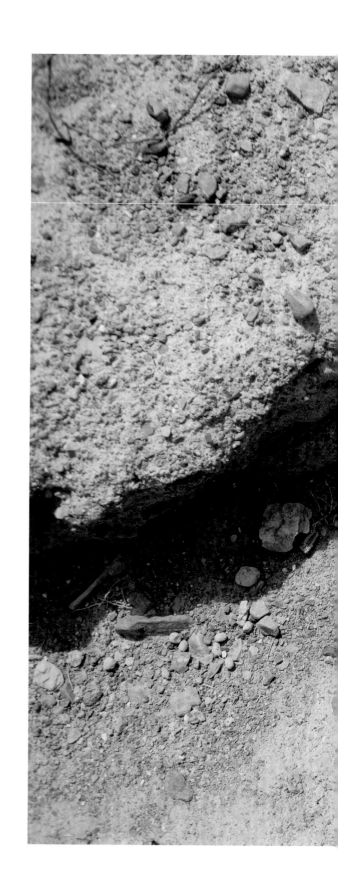

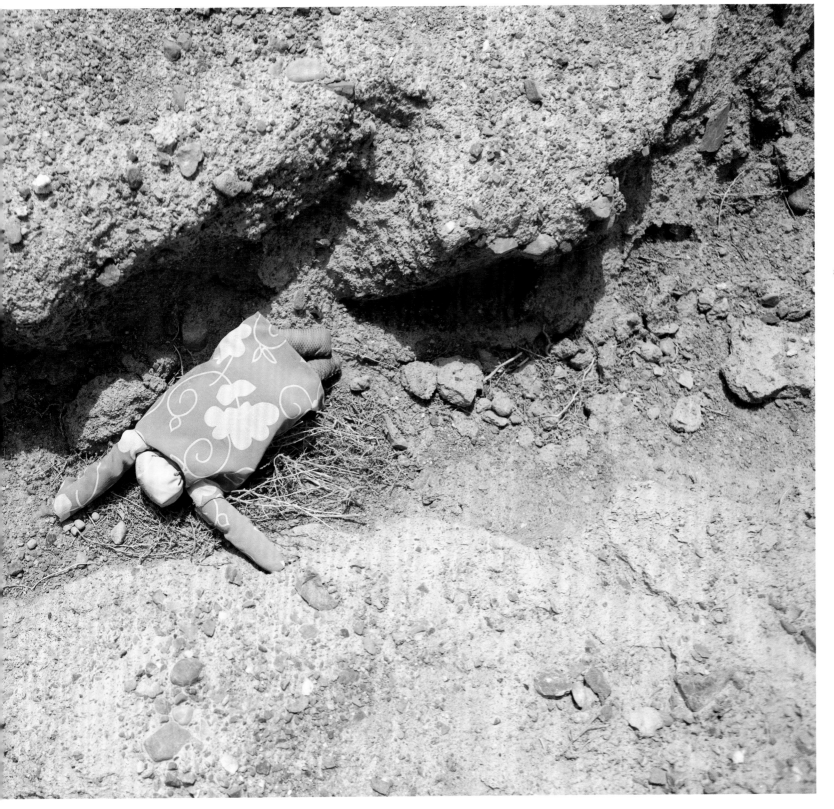

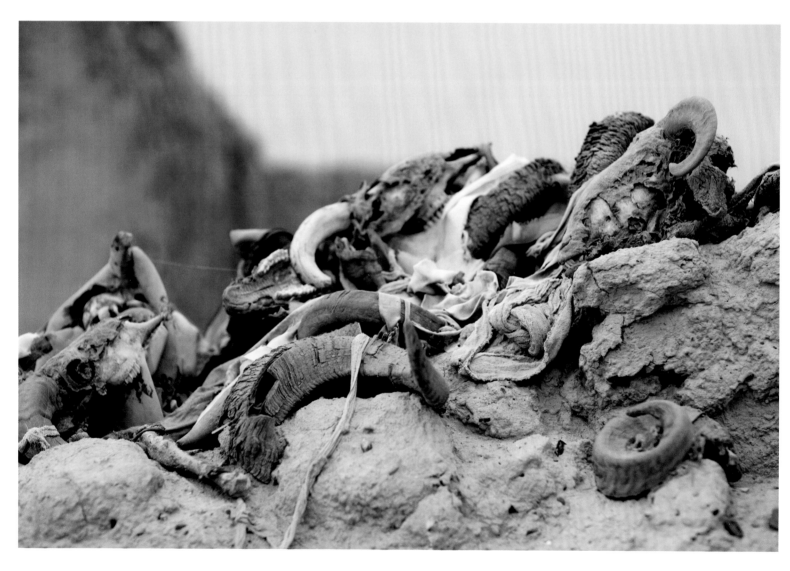

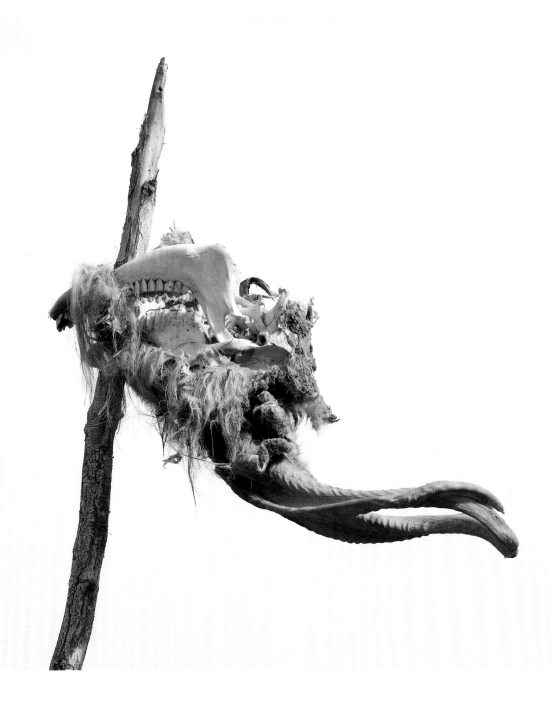

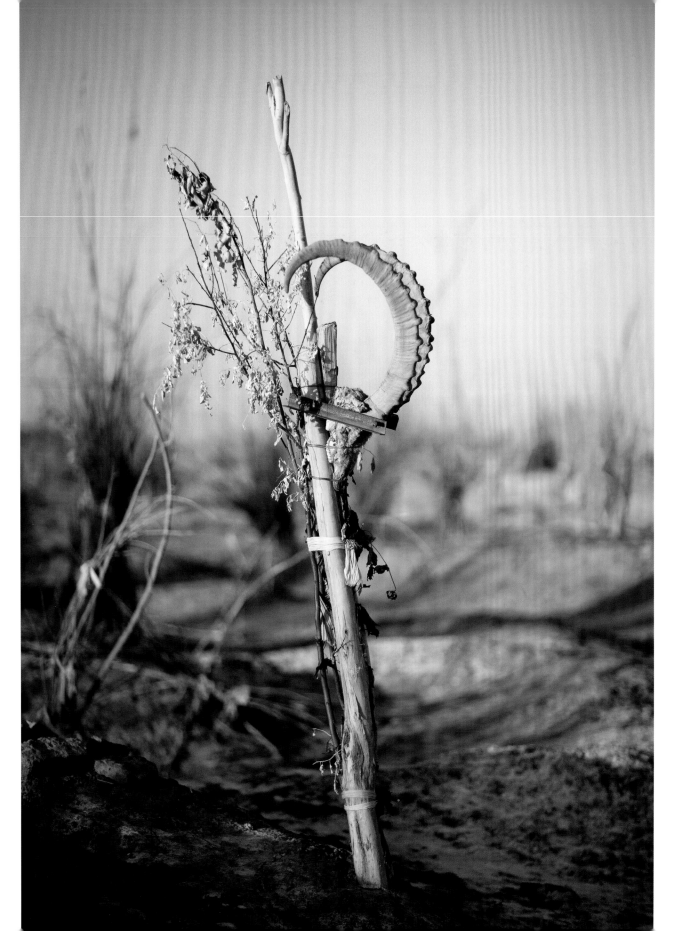

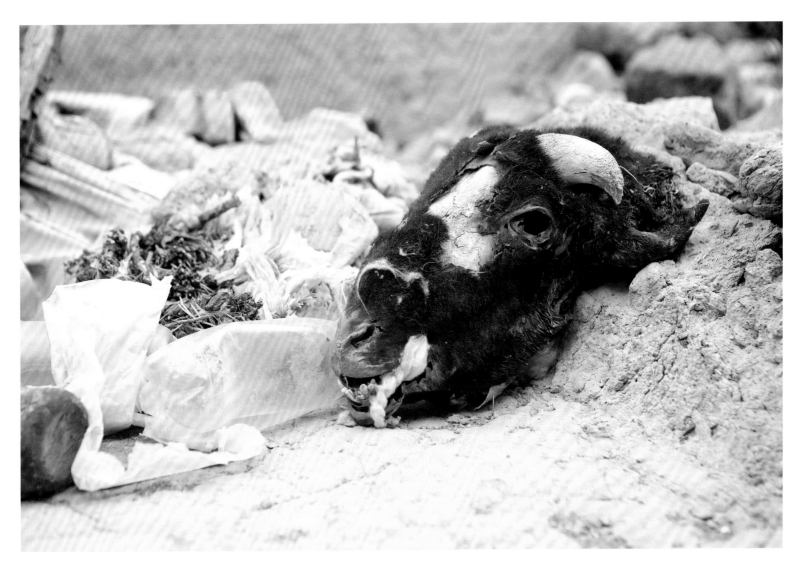

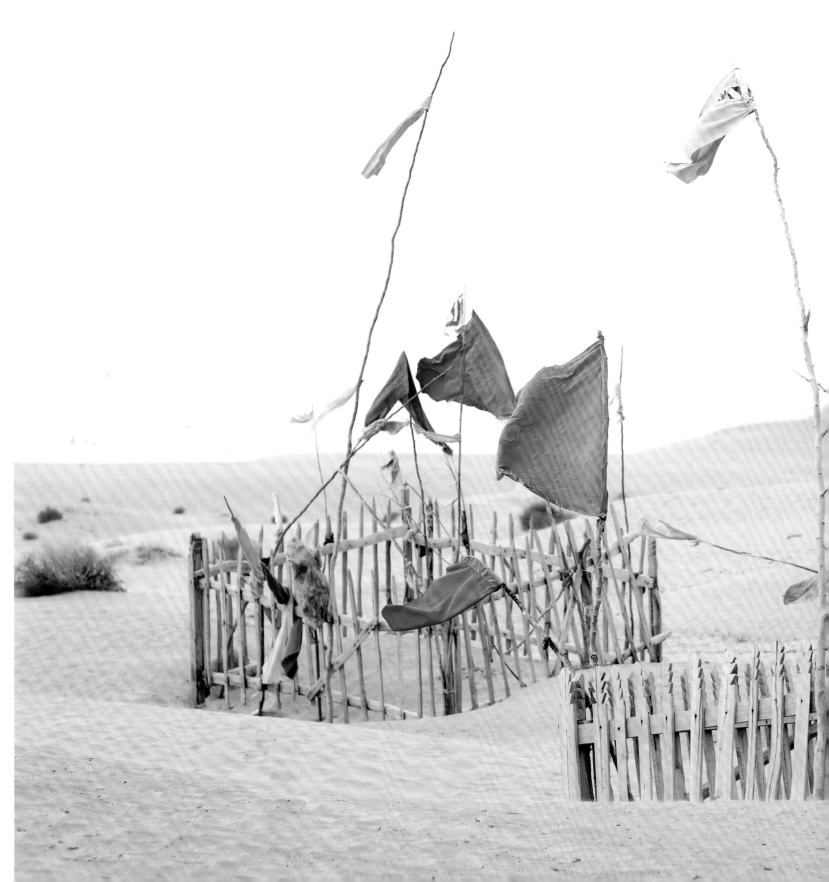

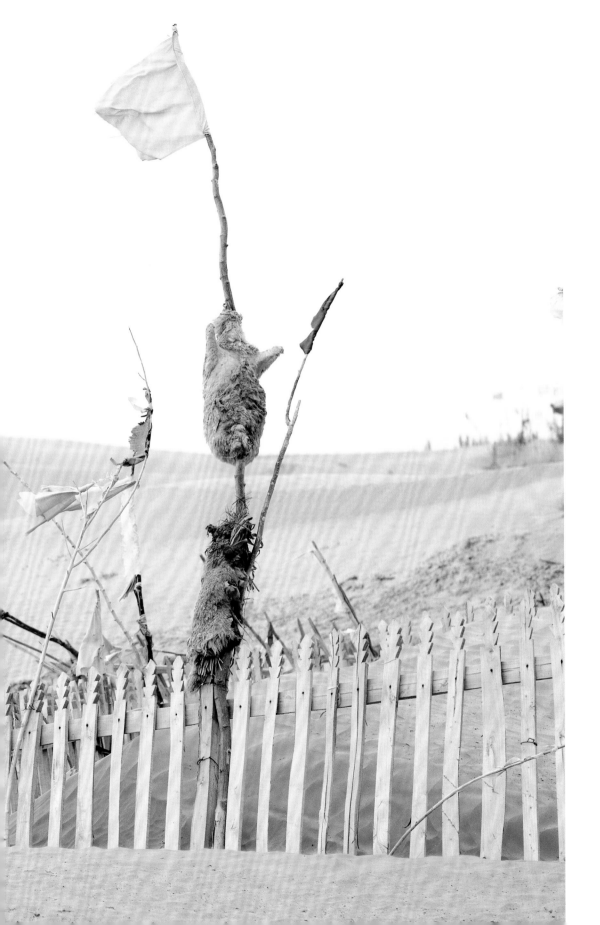

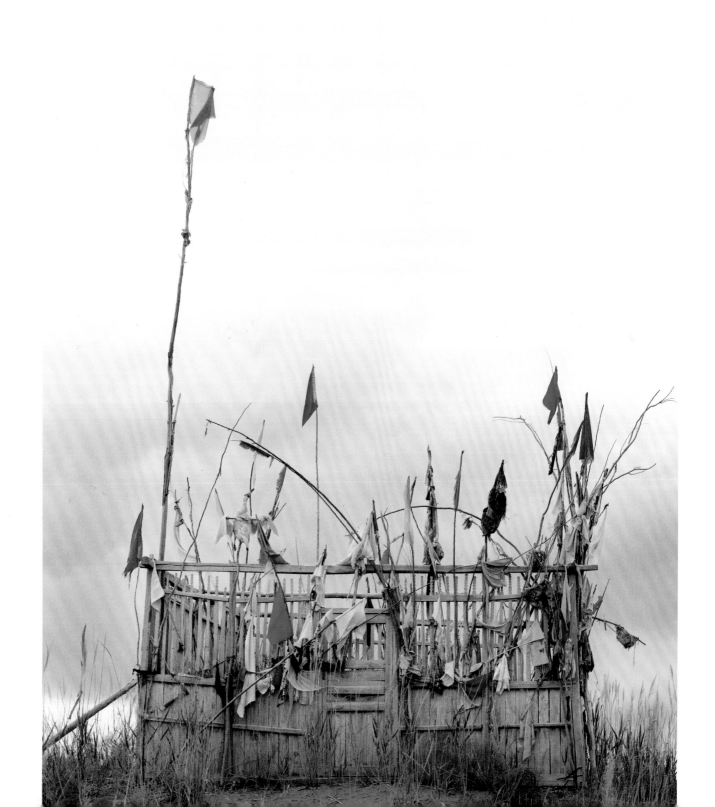

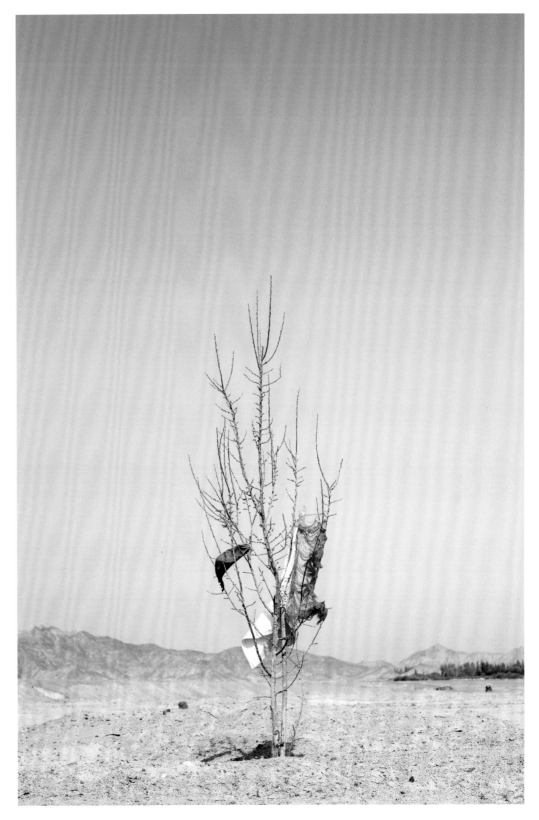

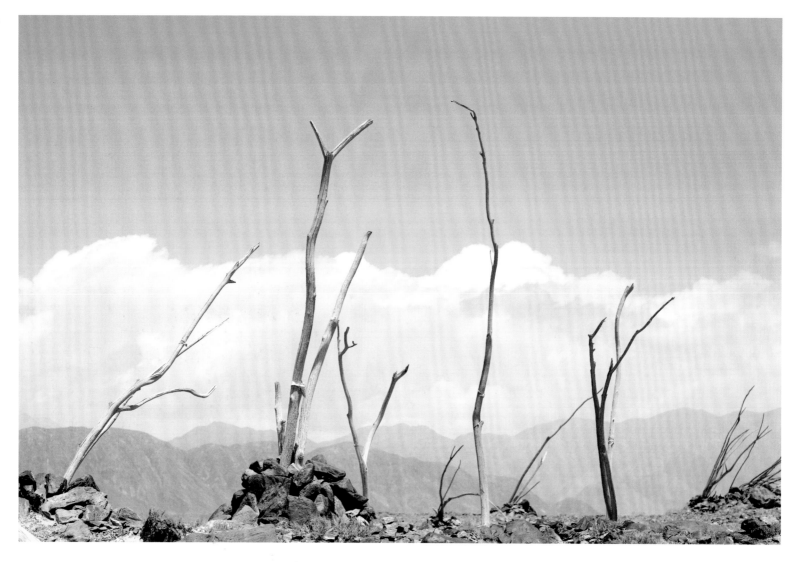

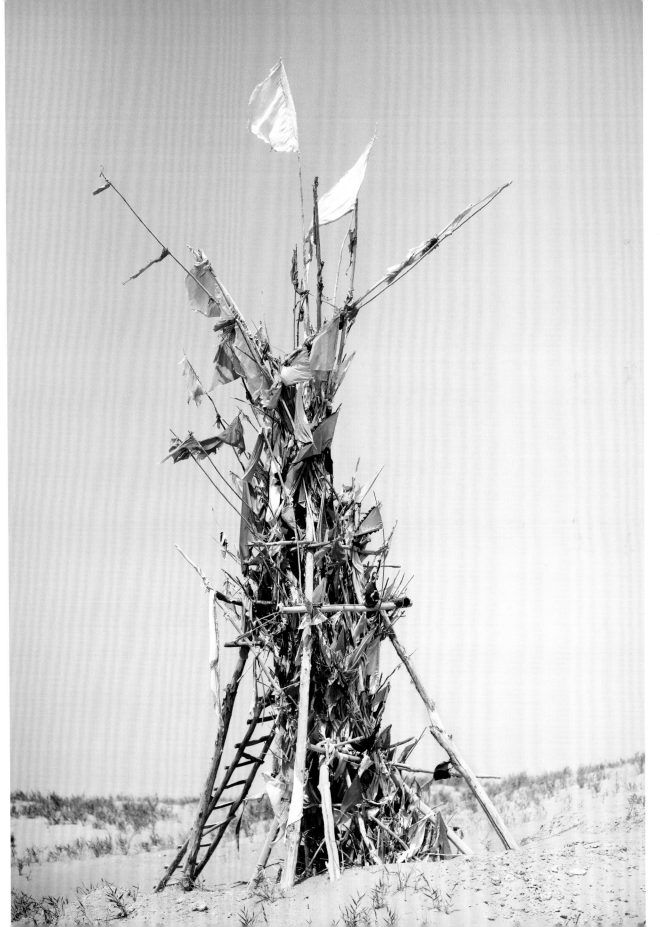

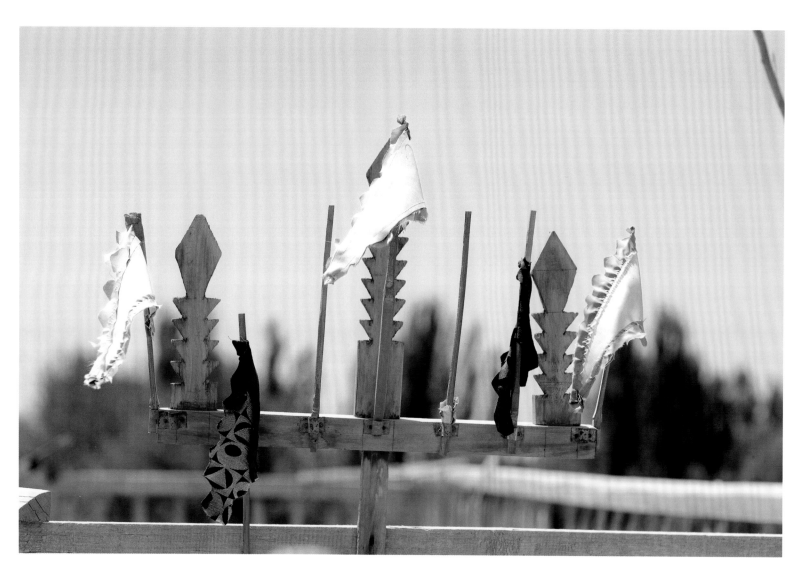

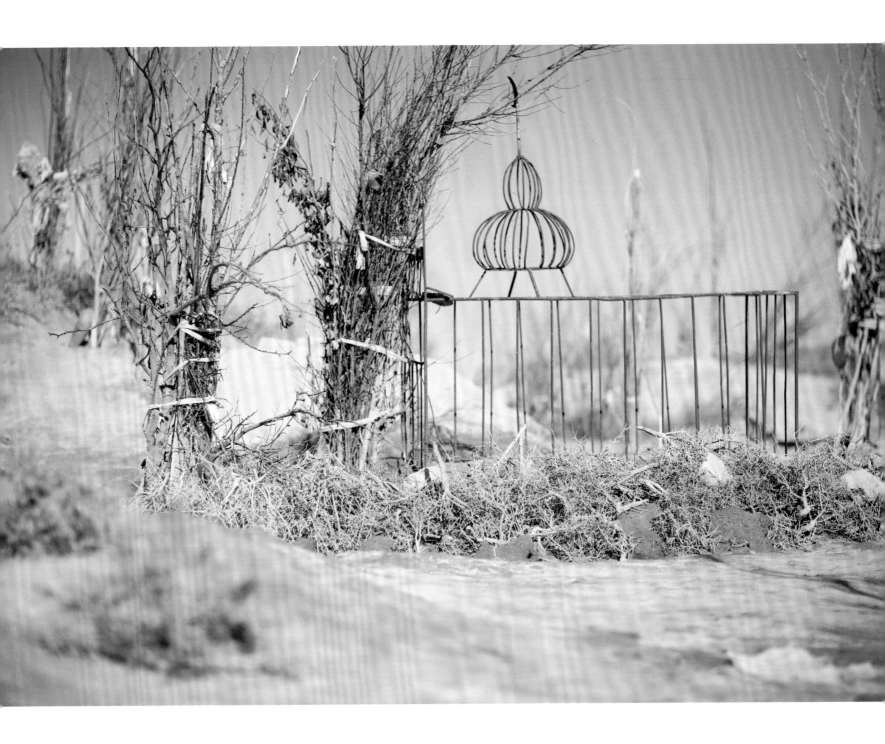

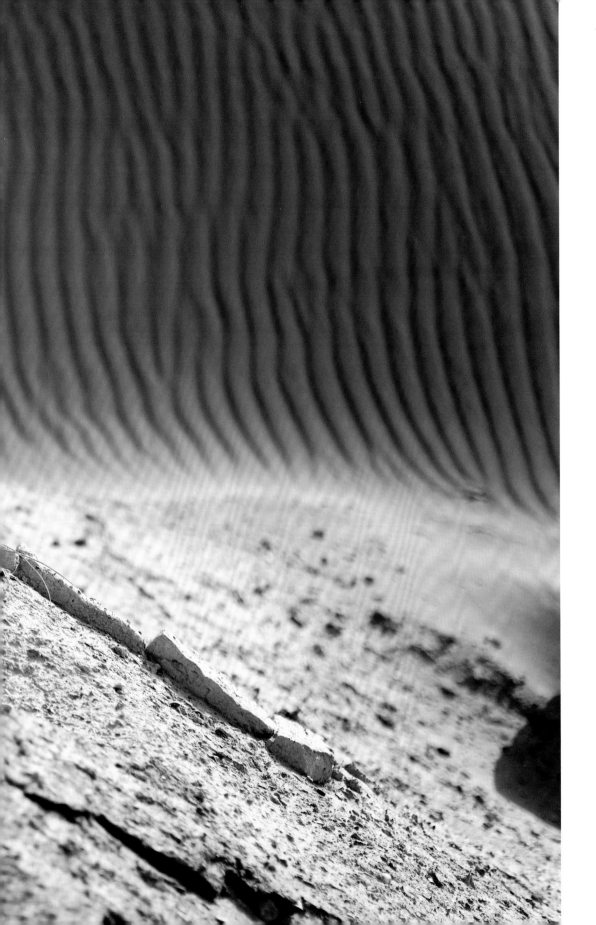

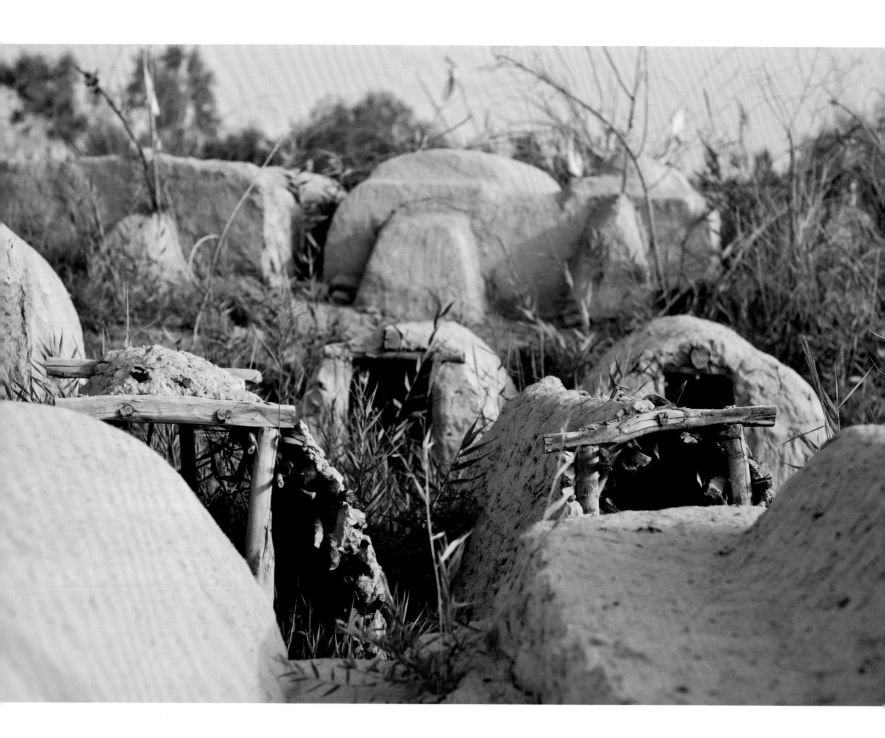

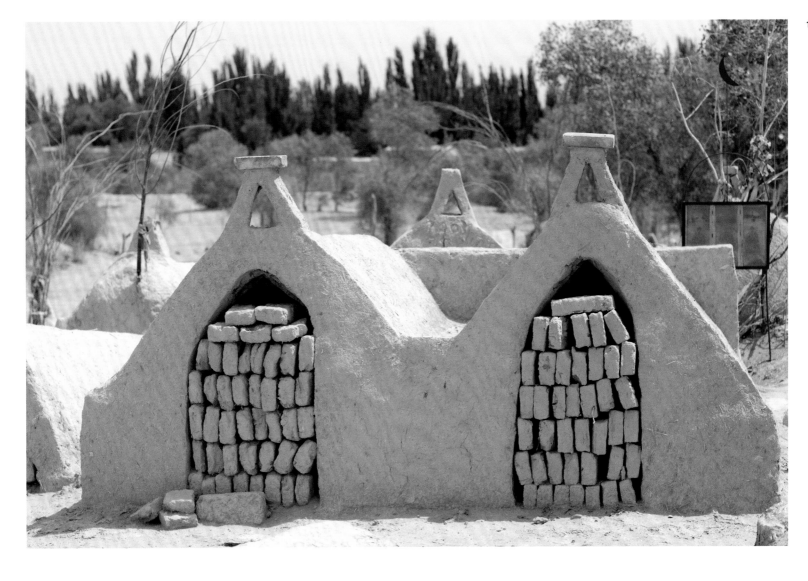

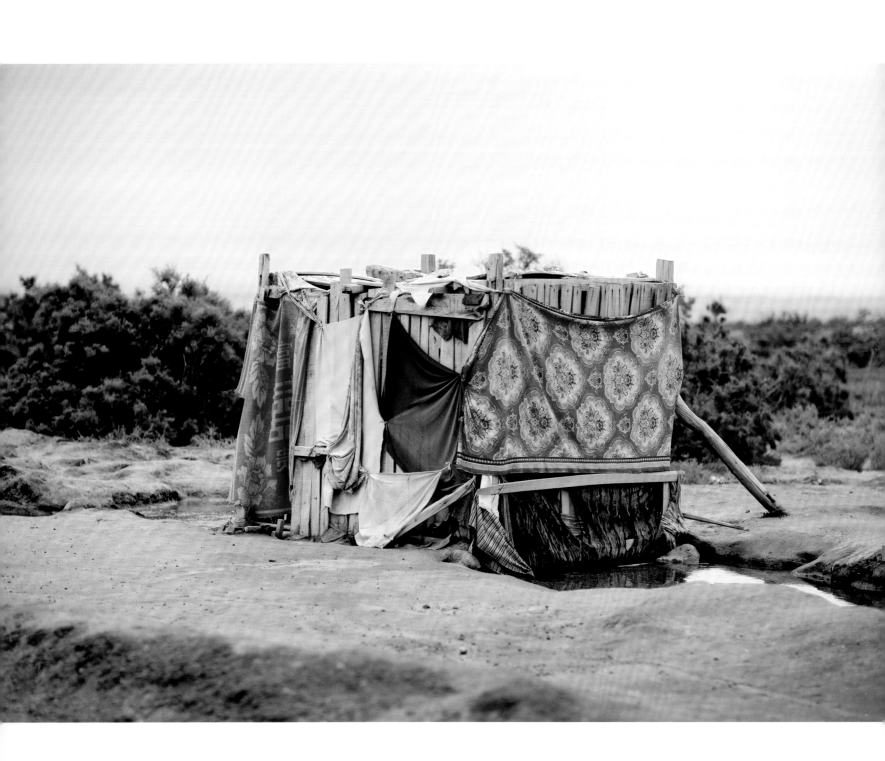

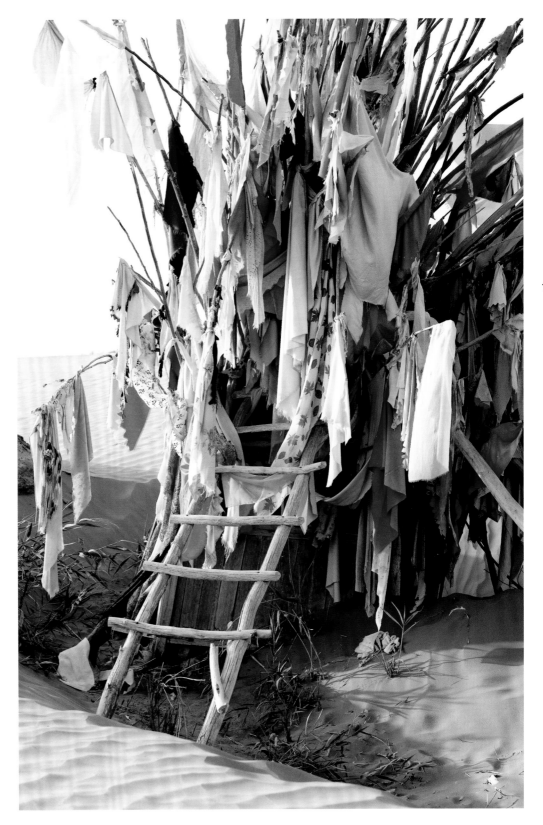

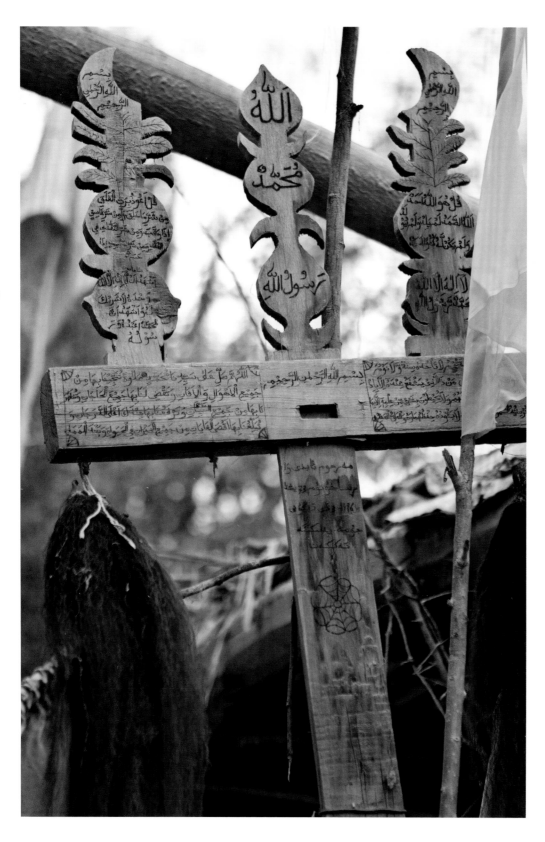

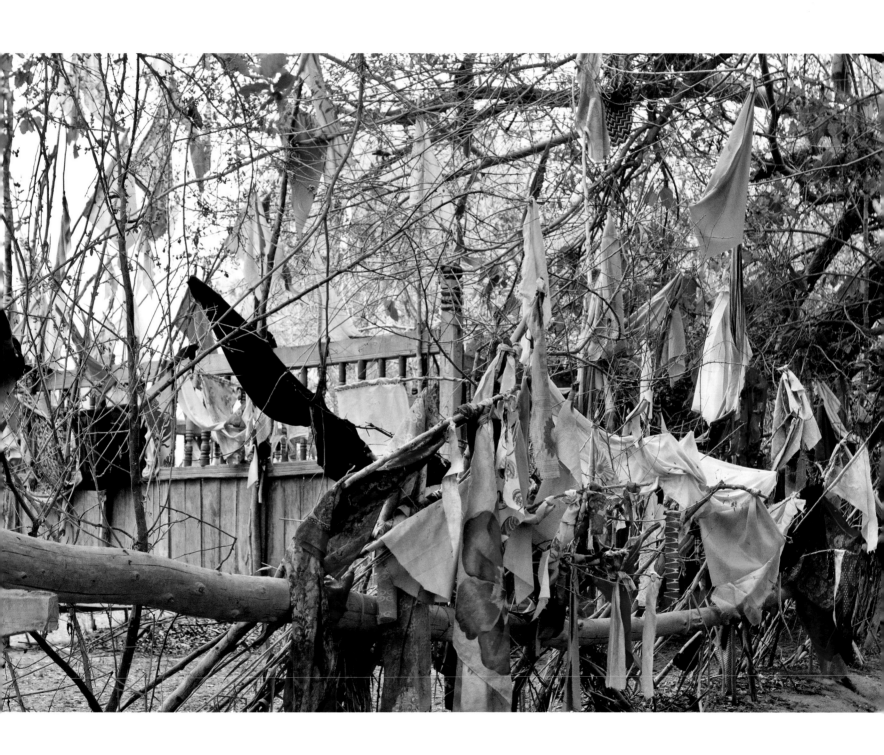

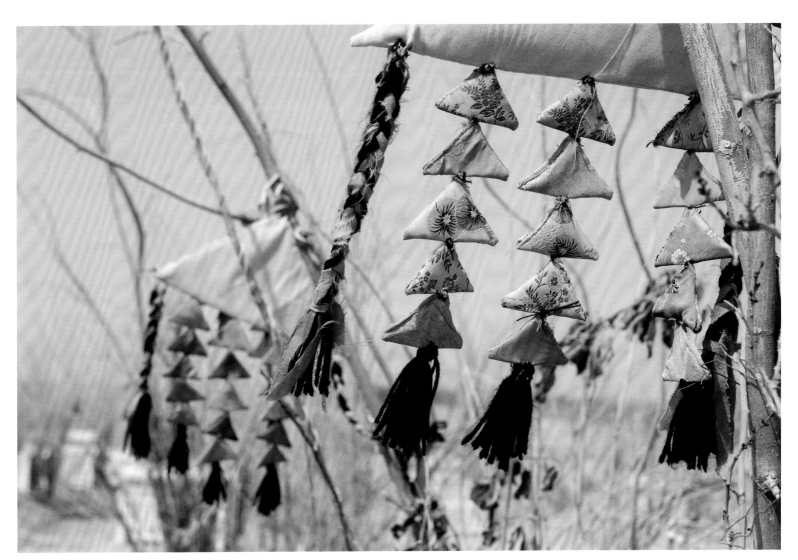

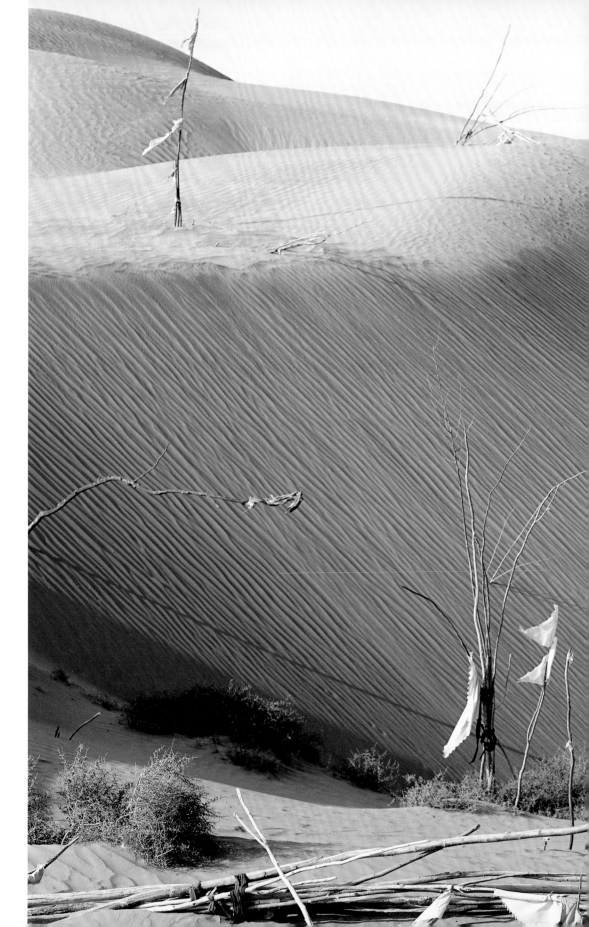

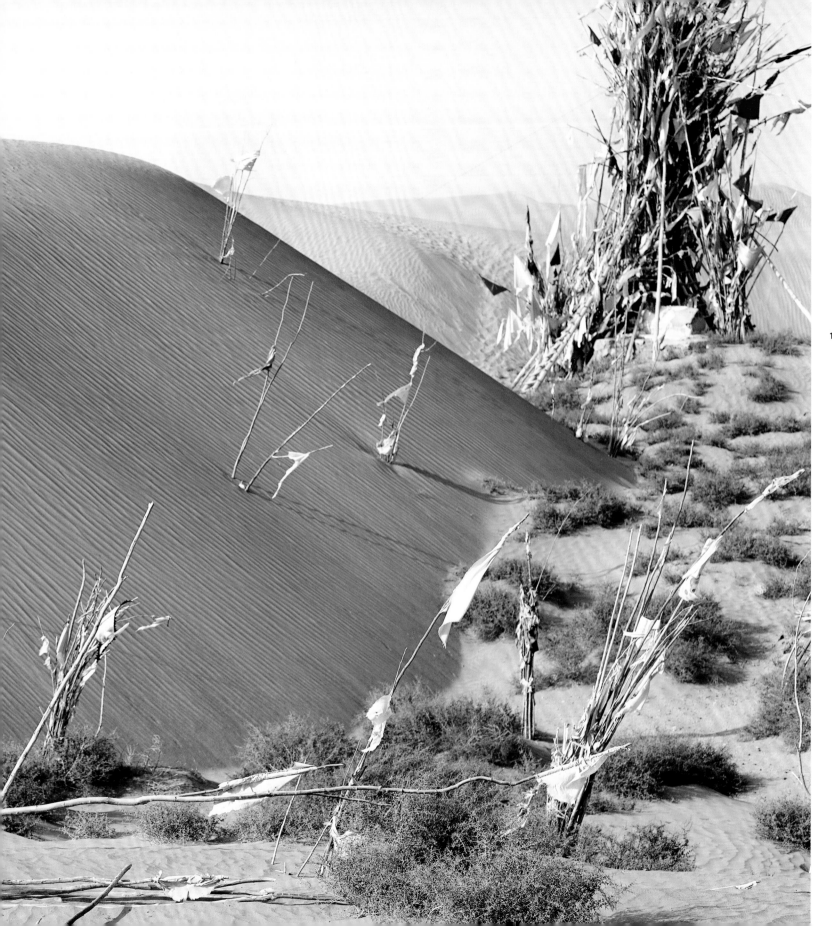

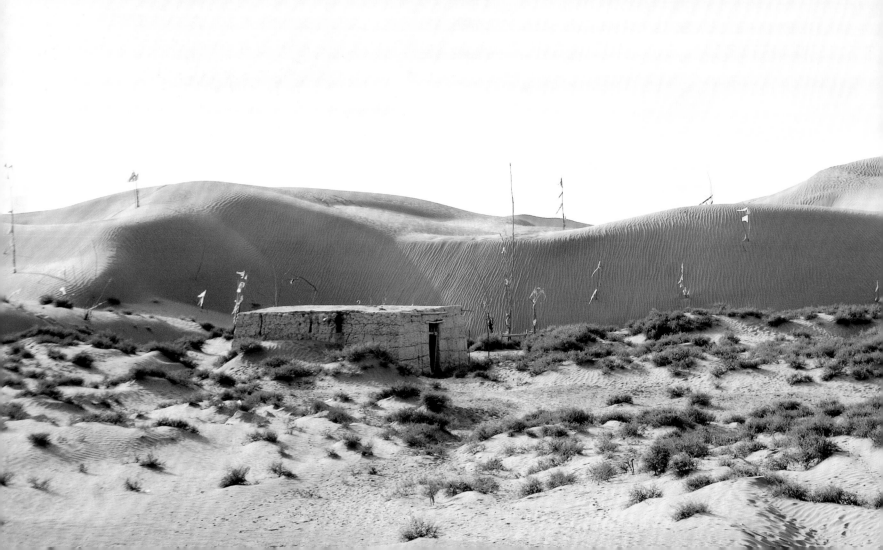

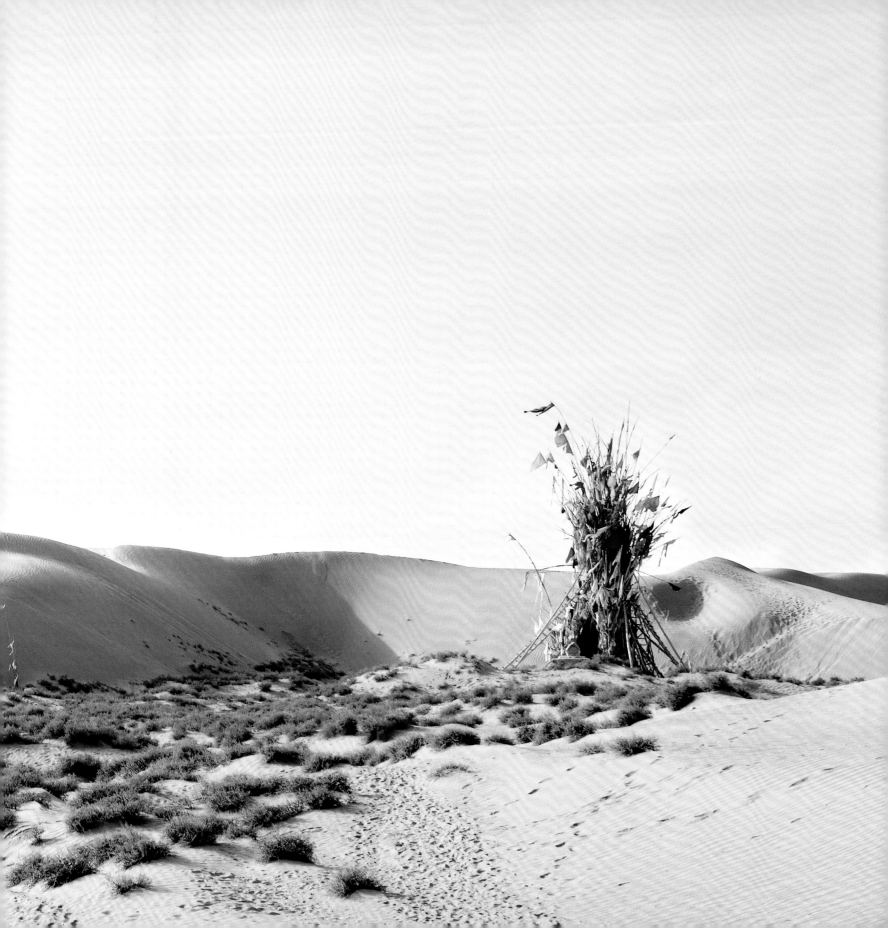

Captions

18–19. *Unrevealed, Site 3 (Harvest Prayers)*, 2010
Markers for saints in the desert are maintained by *shaykhs*, who dig out the sands that would otherwise cover it over time. The number of flags on a marker correlates to a saint's power at performing miracles.

20. *Unrevealed, Site 3 (20 Meters High)*, 2010
Footprints circling a saint's marker are created by the daily visits of pilgrims who come to pray for a rich harvest.

21. *Unrevealed, Site 3 (Tugh-'alam)*, 2009
Tugh-'alam are scattered throughout the dunes either to mark burials, a visit, or a prayer.

22–23. *Unrevealed, Site 1 (Three Gates)*, 2008
Eleven gates lead to the tomb of a saint. Gates are symbolic spiritual entryways or conduits to a holy site.

24. *Unrevealed, Site 1 (Women's Place of Prayer)*, 2006
Women spend time in this *khanaqâh*, performing rituals and prayers focused on fertility and marriage. Visitors leave a scarf or piece of clothing on the outside.

25. *Fertility*, 2006
At a certain point in the pilgrimage to this shrine women, who created it, separate from men. When the fabric blows in the wind it is believed to be capturing evil spirits, before ushering them away.

26. *Unrevealed, Site 1 (Gate of Passage)*, 2006
Gates are decorated with handmade flags, adding to the spiritual power of a walk into the desert.

27. *Unrevealed, Site 1 (Adorned)*, 2006
This prayer site for women only is for fertility, domestic harmony, and love.

28. *Unrevealed, Site 1 (Dialogue)*, 2008
Tugh-alem are carried into the desert on an annual pilgrimage, or at the time a person most needs to visit a specific saint.

29. *Untitled, Site 1 (Blue Scarf)*, 2009
A *tugh* serves as an axis mundi that represents the connection between sky and earth—as if each buried saint plays a role in supporting creation.

30–31. *Unrevealed, Site 9 (Hilltop "Crib" Markers)*, 2006
Rectangular fence markers protect burials; they vary in materials and construction from region to region.

32–33. *Burial Branches Reaching*, 2012
The majority of grave markers have no name or writing on them, yet the family members are aware of which graves belong to their ancestors.

34–35. *Unrevealed, Site 4 (Colored "Cribs")*, 2009
Painted burial markers are protected by a stand of poplar trees.

36. *Unrevealed, Site 4 (Yellow Marker)*, 2009
Rice and corn tied to markers "feed" evil spirits and protect buried souls.

37. *Wooden Garden*, 2012
Wooden flowers are carved as decoration on fencelike markers. Visitors use pencil to record their names and the dates when they were there.

38. *Hillside Markers*, 2010
In the southeast of the Taklamakan Desert, yak tails hang as talismans on top of tall branches.

39. *Red Flowers*, 2010
Red flowers, painted wood, and bunched branches adorn two isolated burial markers.

40. *Two Crescents, 1988*, 2011
A wood-and-metal burial marker adorned with the cresent moon of Islam mimics the architecture of a mosque.

41. *One Hundred and Nine*, 2006
Although many burial markers are anonymous, some state the name and age of those who have passed. This man lived until he was one hundred and nine years old.

42. *Black Garden (Single Twig)*, 2009
Small markers are created by family members for their loved ones. This marker is only eight inches high.

43. *Black Garden (Gathered Twigs)*, 2009
Individual markers are portraits of those who have passed as well as portraits of those who make them and visit frequently.

44. *Black Garden (Yellow Fringe)*, 2007
Flags sometimes have fringe sewn along the edges.

45. *Black Garden (Blue and Pink Marker)*, 2007
The small markers look fragile, yet are strong enough to withstand the elements of wind and sand.

46. *Black Garden (An Offering)*, 2009
Small bottles filled with oil are sometimes left as offerings for the dead; the oil may be used for burning wool, a ritual activity at some *mazârs*.

47. *Black Garden (Blue Crib)*, 2009
A landscape of diverse markers.

48–49. *Black Garden (Baraka)*, 2009
The dead are believed to benefit from the spiritual power, or *baraka,* of being buried in close proximity to a saint; *qabristanliqi* like this one often surround tombs.

50. *Black Garden (Tandem)*, 2009
Two markers, coupled in an isolated area.

51. *Black Garden (Broom)*, 2010
Brooms may be tied to a burial marker in hopes of sweeping away evil spirits.

52–53. *Unrevealed, Site 1 (Trees and Shelter)*, 2007
Many graves and ancient desert trees line the path that leads to a great saint's marker. Shelters have been built so pilgrims may spend the night, as a journey to a *mazâr* is far for many. It also offers respite from the high heat of the day and can be used as a place to have small meals.

54–55. *Black Garden (Crib with Door)*, 2009
Some markers have small doors that allow family members access to leave food for the spirits.

56. *Unrevealed, Site 1 (Above and Beneath)*, 2008
Sand eventually covers markers in the windy desert; they need to be dug out when this happens.

57. *Healing Tree*, 2009
Natural formations are also known to have the power to heal, and may be the center of a *mazâr*.

58. *Child's Braid*, 2009
A child may be taken to a *mazâr* in order to have her hair cut and left as a prayer for long and healthy life.

59. *Two Dolls*, 2009
Two *qorchaqs* left in prayer for fertility.

60. *Blue Dress*, 2009
Shamans or *buwi*, female religious teachers, will often prescribe that a woman leave a *qorchaq* at a *mazâr*.

61. *Doll with Yellow Tile*, 2009
A *qorchaq* with a scarf and a dress, representing a woman.

62. *Doll, Rock, Bowl*, 2009
Food may be left alongside a *qorchaq*, in bowls.

63. *Doll and Colored Glass*, 2009
A *qorchaq* left near the tomb of a saint.

64. *Womb and Fetus*, 2009
An arched twig with a small figure inside represents pregnancy.

65. *Brick Figure*, 2009
Handmade bricks in the shape of the human form are used as a burial marker in a desert *mazâr*.

66–67. *Unrevealed, Site 12 (Bricks with Muslin)*, 2009
Bricks bound together with muslin create an animated form atop a burial.

68. *Bed Frame Burial*, 2010
Bricks and part of a bed frame illustrate diversity of form in creating burial markers for loved ones.

69. *Unrevealed, Site 12 (Tomb with Can)*, 2010
It is unusual to see a headstone with this shape in more ancient *mazârs*; the can on the branch is placed intentionally, but is also an uncommon offering.

70–71. *Unrevealed, Site 12 (Four Branches)*, 2009
Footprints lead up to four bare holy markers in the dunes.

72–73. *Unrevealed, Site 5 (Six Awaiting)*, 2009
Future places for burial close to the tomb of a saint are carved out of soft mountain stone.

74. *Window*, 2007
A mausoleum with a single window allows light to connect the living with the tomb of a saint.

75. *Stone Hearth*, 2010
This symbolic structure is left in prayer for domestic harmony or a wish for a house.

76. *Unrevealed, Site 20 (Sunray on Tomb)*, 2009
Mazârs are often cared for by generations of *shaykhs* from one family, and may be in close proximity to their homes.

77. *Unrevealed, Site 11 (Golden Tomb)*, 2009
Books at the head of this tomb contain Quranic texts and the saint's history.

78–79. *Unrevealed, Site 18 (Remembrance)*, 2009
Burial mounds constitute an ancient *mazâr* under the setting sun.

80. *Ram's Horns*, 2009
Remnants of a sacrifice.

81. *Bird's Head*, 2009
When an animal sacrifice is performed, the animal's body is cooked and eaten in ritual.

82. *Four Rams' Heads*, 2009
During holidays such as *'ayd qurban*, many rams may be sacrificed.

83. *Goat Head in Muslin*, 2009
A goat's-head talisman.

84–85. *Weathered Qorchaq*, 2009
Aged and weathered, a doll has begun to merge with the earth.

86–87. *Pink Doll in Crevice*, 2009
A *qorchaq* placed in a crevice may be symbolic of the birth canal.

88. *Over Time #2*, 2009
A wall of horns and rams' skulls left in prayer.

89. *Over Time #1*, 2006
A ram's-head sacrifice marks an ancestor's burial.

90. *Crescent Ram*, 2010
Steel bars connect a ram's skull to its wooden support to ensure permanence.

91. *Braided Wool*, 2011
A recently sacrified animal head among other ritual material.

92–93. *Unrevealed, Site 2 (Red Movement)*, 2009
Interconnected by wind and sand: *tulums*, branches, *mazârs*, and saints.

94. *White Bird*, 2010
This saint's tomb is surrounded by high walls, many *tugh-alem*, and numerous sacrifices, such as a white bird with wide-open wings.

95. *Burning Branches*, 2009
Dug deep into the ground is a dead tree without roots, wrapped in bright colors.

96. *Bare Branches*, 2009
This *mazâr* with a long and important history has become illegal for pilgrimage; a "new" version has been set up by a Chinese company for tourists at the bottom of the mountain, where an entrance fee is charged and the related history altered.

97. *Prayers and Wishes*, 2010
Numerous *qorchaqs* are tucked in and around this *mazâr*'s tall branches; women come here to seek cures for loved ones, often children and the unborn.

98. *Sacred Ornamentation*, 2009
A *shidde* with wooden appendages and small flags.

99. *Wire Dome*, 2010
Handforged metal replaces the more usual material of wood for a rectangular burial marker.

100–101. *Unrevealed, Site 12 (Infinity)*, 2009
Desert winds and moving sands accentuate the passage of time.

102. *Shelters*, 2011
Coverings for the burials underground made by hand of clay, straw, and branches.

103. *Portals*, 2010
Handmade brick offers protection to underground tombs.

104. *Unrevealed, Site 6 (Ritual Bathhouse)*, 2009
Turquoise water springing from a small mountain creates a stream that is believed to have the power to cure disease. This shelter is used for bathing in private and in prayer.

105. *Unrevealed, Site 3 (Ladder)*, 2009
A ladder at a *mazâr* symbolizes the voyage between earth and heaven.

106. *Sacred Ornamentation with Words*, 2010
A *shidde* with Quranic surat honors Waris Akhunum, aged seventy-three, who died in 1996.

107. *Fabric-Filled Prayers*, 2010
An entire village came on pilgrimage to this site, praying at five different saints' markers—this was the first stop on their route.

108. *Amulets (Vertical)*, 2008
Amulets are good-luck charms. They are left to honor the deceased and to cleanse the spirit.

109. *Amulets with Braid*, 2008
Instead of leaving a piece of material or a flag, people sometimes sew and bring amulets from home as markers and gifts for those who have passed.

110–111. *Landscape Meets Prayer*, 2009
In addition to a large physical marker for the *mazâr*'s main saint, the nearby landscape is covered with numerous other markers for prayers, lesser saints, and the dead.

112–113. *Khaniqah at Desert Mazâr*, 2009
The lodge to the left of the *mazâr* is a place for various ritual activities, such as religious teachings, prayers, and Friday *zikrs*—remembrances of God.

Abstraction, Aesthetics, and the *Mazâr* in the Art of Lisa Ross

Beth Citron

At first encounter, the desert horizon gives way to a landscape, a construction, a site. Without a referent or context, these places would appear abstract, as images of uncertain scale, depth, or meaning.

These photographs by artist Lisa Ross were taken at *mazârs,* Muslim sacred burial sites, in Uyghur China—known variously to different peoples as Xinjiang, East Turkestan, a stop on the Silk Road, Chinese Central Asia, or Uyghuristan. This region has long been one of the world's great crossroads, with a cultural distinctiveness built from a history of hybridity. Indeed the vernacular, often-spontaneous sites that Ross has photographed suggest an experiential in-betweenness and a semblance to things and places found just beyond the expanse of the Taklamakan Desert: prayer flags from Tibet, wishing trees in Mongolia, and even the mundane, mass-produced acrylic silks littering China's towns. On closer inspection, however, the distinctions of these *mazârs*—and those of Ross's work—begin to come into focus.

What we are seeing in these photographs—even more than the apparent subject of the *mazâr*—is Ross's remarkable ability to reveal simultaneously her personal encounter with these sites, and also to let us face them for ourselves. In Ross's photography, the *mazârs* appear at once resilient and vulnerable, grounded and otherworldly, strangely beautiful while materially commonplace. Ross presents us with the full complexity of these sites, and their seeming paradoxes, through her careful decision to leave the human figure out of the frame. She looks, slowly, and waits, with patience, for the place and her photograph to become available—the absence of any figures opens up the possibility of abstraction. By resolutely photographing these sites of pilgrimage without pilgrims in them, Ross has chosen not to orient or mediate our perceptual encounter with these *mazârs*. Instead, the viewer must navigate the unfamiliarity of the *mazârs* and these images alone, assessing the scale of the crib-like burial markers by their dwarfed relation to the lanky trees in *Unrevealed, Site 4 (Colored Cribs),* and grasping the outsized, sandy sweep of the desert from the distant grave markers in *Unrevealed, Site 3 (Tugh-alem).* Ross's photographs are rich mediums of discovery, on the emotional intensity

inherent in these sites and on the nature of her deep engagement with these places. In setting up this process of self-led questioning and in inspiring our desire to look carefully at details, Ross invites us to recognize the visual beauty, visceral ardency, and sacred gravity of these sites. She also lets us experience the specific moment when she was there.

We can, of course, find traces of human presence at these *mazârs*: in animal offerings, flags, and colorful silks fixed to varied markers, and in the hollows and footprints in the sand—all left behind by pilgrims and passersby. Unlike the extravagant phenomenon of this landscape and the enduring structures of the *mazârs*, however, such traces are necessarily fleeting and often forgotten. Each of Ross's photographs speaks, then, of a unique convergence of natural and personal encounters, which are records made more significant by recent modernization attempts of the Chinese government that threaten to turn these living shrines into relics or tourist sites. Despite her choice to remain apolitical in her work, Ross nevertheless captures the critical decade in which the social and political context around these *mazârs* changed, making both their continued usage and these images all the more meaningful. This recent history has also coincided with a decade in which the West's already-tenuous image of Islam has been deeply and dangerously upended; these *mazârs* reveal a valuable alternative to existing stereotypes, offering us ideas and places built on and by a grounded spirituality. As represented by Ross, these *mazârs* evoke a sacredness that resonates far beyond their religious affiliation or intended function—they reflect the essential, spiritual experience of wonder coupled with humility. In light of the challenges—there as well as here—that this decade has brought, the *mazârs* impress upon us the dual nature of their handmade humanity and the culture's delicate fragility.

For Muslims in Uyghur China, these *mazârs* are sacred sites that commemorate saints and great persons; both the *mazârs* and the surrounding desert are inflected with life through the offerings and presence of devoted pilgrims. In her photographs, Ross shows us that this desert landscape is also inherently alive and vibrant—we can feel and almost hear the gale roaring through the bare markers and flags in *Unrevealed, Site 3 (White Flag),* and can sense the tall, thin trees and shrubs reaching up and growing green around the markers in *Unrevealed, Site 4 (Colored Cribs).* These two forms of life are interwoven. They are revealed to us through the rigor of two different types of practice: ritual and artistic. Both are extensions and expressions of a spiritual process. This dimension of Ross's work is all the more astonishing when considering how unusual it is for an artist working within the (secular) contemporary art sphere to take on a sacred subject from a remote place and culture and to instill it successfully with her own affective vision and sensibility. To this Ross has also brought an attentive commitment paralleling that of the more traditional visitors to these sites. Like the religious pilgrim, the artist traveled to and through these sites on a deliberate journey invested in the creation of meaning with its own set of rites and relationships. Ross's photographs recognize and distill a mystical vision—in which the parallels between ritual and artistic practice harmonize subject and subjectivity, and where the competing powers of the human and natural presence are resolved.

These *mazârs* are simply not seen in aesthetic terms in Uyghur China. This is critical to understanding the vision and precision in these photographs, in Ross's honoring of the intrinsic balance at each site—between the sensory bareness of a constructed *mazâr* and a surrounding air of ecstatic greatness. The beauty of Ross's work is borne from this honesty, and that is what allows us to explore the aesthetics of these *mazârs* without an Orientalizing gaze.

At first sight, these photographs raise fundamental questions about what they might be: abstraction or landscape, natural occurrence or physical construction, human intervention or otherworldly object. As facts and evidence gradually reveal the subtle and symbolic, these photographs continue to propose further, more complex, questions—about perception and how we discern meaning—and also suggest a rich range of answers that mirror the resilient, remarkable, and complex life of these living shrines.

An Interview
with Rahilä Dawut

Excerpts from an interview conducted with Su M. Manzi on May 8, 2012, in New York City.

How did you and Lisa meet?

We met in London at a conference on Uyghur culture at The School of Oriental and African Studies. I was amazed to see my book in her hand—torn, dirty, and full of notes. Alexandre Papas had come across my book in his research and together, they visited numerous *mazârs* in Xinjiang. I never imagined two foreigners would use my book, which was intended as a guidebook for Uyghur pilgrims, in this manner.

 The following year Lisa and I traveled together, after I had returned home to Urumchi. I helped Lisa to see much more of Xinjiang while she helped me learn about photography for my fieldwork. At first, I did not have a clear idea of Lisa's mission. But when I saw the way she made images of sites that Uyghurs do not consider "artistic creations," I began to understand.

In a few words, what is the essence of *mazâr* practice?

Mazârs provide an ecological and spiritual balance in a Uyghur community. A beggar I once met said: "Mazâr aman, el aman. El aman, hukumet aman." The literal translation is: When the *mazâr* is at peace, the people are at peace. When the people are at peace, the rulers are at peace. I personally believe that this is true.

What is the main function of this practice?

The functions of the shrines are numerous. One of the most important reasons for shrine visitation is to address community affairs and the basic needs of the village, such as agricultural needs. If a village needs water, the whole village comes together and everyone makes an

individual offering in order to receive a solution for the communal problem. Sometimes people also go on a pilgrimage in a large group, take offerings from people in their community, and bring these objects and sacrifices to a shrine, leaving them for the spirits of saints. When it rains and they finally receive water, it's attributed to the saint or holy site.

The second purpose would be for personal needs and problems, such as infertility. If you can't have a baby, you go to a *mazâr* known for fertility. Or, if you are pregnant, you may go there to pray for the well-being of your baby. The history of a shrine is less important than its current function; many of the shrines' actual histories and religious initiations have been forgotten over time. It is through a specific function that shrines derive their real meaning for the people who visit them.

Can you say more about what people receive from shrine visitation today?

It's difficult for people to communicate from village to village. Villages are so far apart. Big shrine festivals give them the opportunity to see each other, exchange information. Also, they come together to have fun. Shrine pilgrimage allows them to have unity. One may say this reinforces cultural and economic exchange, community ties, and provides entertainment through music and folk singing.

Let's take Ordam *mazâr*—although pilgrimage there is now banned. It was one of the largest and most important annual pilgrimage sites. Ordam is located in Kashgar, in the desert. People came all over from surrounding areas and directions to meet there. Over 100,000 people would gather at one time, and some even found a future wife or husband at these visitations. They traveled with donkey carts over a span of days or weeks, having fun along the way: cooking, eating, talking, and singing. The whole activity of shrine visitations becomes relaxing, cathartic, and communal.

Although shrines are named after saints and important people, the visitors are more concerned about their spiritual power. They focus their feelings, on wishes and healing. The function of curing and answering specific needs takes priority. Their personal experiences and prayers become the shrine's history.

The need to express spirituality has been present in the Uyghur people before the spread of Islam, and even before the spread of Buddhism. In the Shamanistic period, people thought Tengri / Ulgin (God) and Umay (the Goddess of the Earth) were in the sky. They wanted to give sacrifices to these gods. So they erected tall poles and attached objects to the top of the poles. When Buddhism took over, animal sacrifices were shunned, so instead they gave small coins and flags—but always maintaining the ritual of gift-giving.

Throughout the centuries, people's needs have not changed. They still want cures for disease and have a desire for happiness and healthy children. Only the specific form of giving has changed.

How did you decide to focus your academic research on holy sites? And what drives you to keep this research a priority?

My interest in *mazârs* stems from the fact that they have existed in the Taklamakan Desert for centuries. With fieldwork, I am able to map the cultural landscape of the Uyghurs. The shrines are evidence of Uyghur identity expressed through material culture and spiritual culture. Most important, this is where people come to "clean their soul." It is our history and way of life that we must document.

If one were to remove these material artifacts and the shrines, the Uyghur people would lose contact with earth. They would no longer have a personal, cultural, and spiritual history. After a few years we would not have a memory of why we live here, or where we belong. That's why I feel I must record the history of these shrines. So if or when things change or disintegrate, I can show our history and where my ancestors lived. I have visited and recorded most of the shrines that are still in existence.

How do you view Lisa Ross's photographs in relation to *mazâr* study?

Originally, I thought when people put a piece of cloth on the *mazâr,* they were wishing for something and expressing needs and feelings through this material—that they were not concerned with the color or shape of the fabric. I believed the focus was exclusively on their inner needs and the expression of these inner needs.

In Lisa's pictures, one is able to observe the rituals from outside. On some level I realized the pilgrims do care about the color of what they leave and give thought to how they interact with the shrine. They cut the cloths into certain shapes and tie them up in a certain way. All this care is revealed in the photographs.

Imam-Jafar Sadiq *mazâr* in particular has interesting structures. There are eleven gates made out of branches. I've often wondered how people come here, 70 kilometers into the desert, to build these structures or symbolic doors. Lisa's photographs cause us to reflect more deeply: what is the purpose of these structures?

Even though I've been to certain sites many times, through Lisa's photographs I notice things I've forgotten and overlooked; some things I cannot commit to memory, and other things require answers. Lisa notices very detailed information in the shrines, and afterward, when we are looking at the pictures, she will ask what certain things are, or why people placed certain things where they did. I often realize these are questions I've never thought about. She introduces a new way of thinking about them to me.

Lisa's photos are markers. Years from now, they will help us find our road. We will look at these photos, and understand that this is our history.

Glossary of Uyghur Terms

'alam

Flags, from the Arabic. Fabric or scarves brought by pilgrims to mark a prayer or wish at a *mazâr*. Floating flags symbolize the presence of magical forces and spiritual flux. Tradition holds that when wind blows the *'alam*, bad spirits flee.

bakhshi

An Islamic shaman.

baraka

A saint's spiritual power.

buwi

Female religious teachers.

kiswa

A saint's tomb is usually covered with pieces of fabric furnished by pilgrims or the *mazâr's* guardian. The material is considered a gift and may be offered to signify a vow, wish, or respect for the power of a saint.

mazâr

A *mazâr*, as translated from Arabic, refers to a holy place or shrine and specifically to a tomb or mausoleum. A *mazâr* is a saint's sacred burial place in Xinjiang and much of Central Asia. *Mazâr* are countless and spread across the province. They may be located in a city or a village but they are more often found in remote areas of the desert, far from any village setting.

There are three types of *mazâr*, varying in size and complexity:

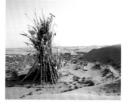

The first is the largest and most complex; these are fewest in number. A complex *mazâr* houses either a tomb of a single saint or tombs of numerous saints buried in a large mausoleum or in the surrounding area. A mosque; a *madrasa*, or Koranic School; and a *khanaqah*, room for Sufi gatherings or prayers are located near the largest *mazâr*. Usually, a large number of people are buried on the grounds surrounding a saint's tomb.

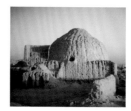

The second type of *mazâr* is more simple, consisting of a mausoleum with a tomb of one or more saints inside. Numerous burial mounds of local people surround this type of *mazâr*, and family members come to visit them.

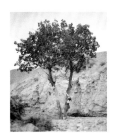

The third type of *mazâr* is the simplest. This will be either a single tomb or a natural geographic formation considered sacred. *Mazârs* are visited regularly by pilgrims. During annual religious holidays, *mazârs* are maintained, decorated, and transformed by large numbers of visitors who leave ritual objects from their homes and villages. Throughout the year, *mazârs* are visited by people in search of spiritual intercession on their behalf. Although visits may occur every day of the week, an emphasis is put on Thursday and Friday visits, since these are important days for both Uyghur ancestral worship and Islamic tradition.

palchi
Seers of the future.

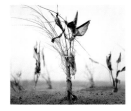

qabristanliq
A Turkic word for cemetery. It is considered auspicious to be buried close to a saint's tomb. The dead benefit from the spiritual power (*baraka*) of the saint. Cemeteries may be extremely large in size and in number of interred people. Grave markers in these cemeteries often vary in style from one cemetery to another, and especially between cemeteries from different geographic regions.

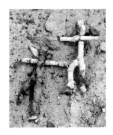

qorchaq
A Turkic word meaning "doll." Dolls are made by shamans or pilgrims and brought to a *mazâr* to aid in the curing of an illness or removal of an evil spirit. For treating ailments, the *qorchaq* is waved over an injured body part and left at a *mazâr* as an offering. The *qorchaq* is also often left by women asking for help with fertility. For ridding someone of evil spirits, shamans rely on the spiritual power, or *baraka*, of the saint.

shaykhs
Guardians and custodians of a *mazâr*. *Shaykhs* maintain the grounds and tomb and assist pilgrims through rituals. *A shaykh* is often initiated by his or her father or mother into the religious role.

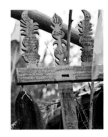

shidde
A wooden carving that functions as an offering and marker. It usually has three or seven appendages or "branches" that face upward.

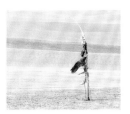

tugh
The Turkic word for poles and branches, which have a central role in *mazâr* practice. They are used to celebrate a saint and mark the sacredness of a *mazâr*. Often made from poplar trees, *tugh* can be made of small branches, but typically refer to much taller versions that reach 40 to 60 feet. The wooden sticks act as a conduit for the spirit to travel through. The taller the *tugh*, the greater the saint.

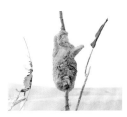

tulum
A Turkic word meaning "skin," a *tulum* is a sheepskin sewn together around a bundle of straw. It is tied to the end of a *tugh* and raised high aboveground. *Tulums* celebrate the holiness of a *mazâr* and the sanctity of the saint.

Map of Western China

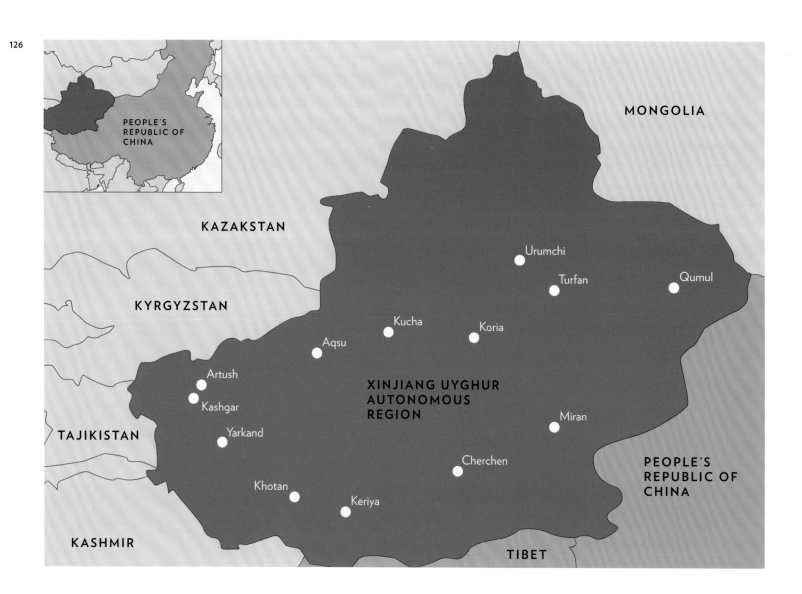

MONGOLIA

PEOPLE'S
REPUBLIC OF
CHINA

KAZAKSTAN

KYRGYZSTAN

Urumchi

Turfan

Qumul

Kucha

Koria

Aqsu

Artush

XINJIANG UYGHUR
AUTONOMOUS
REGION

Kashgar

Miran

Yarkand

TAJIKISTAN

Cherchen

PEOPLE'S
REPUBLIC OF
CHINA

Khotan

Keriya

KASHMIR

TIBET

Acknowledgments

There are many people to thank for helping make this book a dream come true. First and foremost, my deepest gratitude goes to the Uyghur people I met walking the routes around the Taklamakan. They opened their homes and their lives, fed and transported me, shared tea, earth, bread, and roses, told me their histories and songs and led me to their saints; they taught me what little I know about their world. They are the key to everything that follows.

The work this book contains began when my treasured friend Liza Lauber inspired me to join her in Beijing and generously invited me to use her temporary home as a base for travel. Next, my gratitude goes out to the outstanding scholars Alexandre Papas and Rahilä Dawut for their wealth of knowledge and their openness in sharing it in collaboration with an artist. Thanks also to Zulpiye Zumretshah and Halime Abliz for walking into the desert with me. To cherished friend and mentor Max Gimblett for his advice and insisting I find a way to publish this work in a book, and for introducing the work to Beth Citron, who believed in it and brought it to the Rubin Museum of Art. Rachel Weingeist for her continuous confidence and for bringing this work to the attention of the brilliant Gene Smith and many others, to Alexander Gardener for his enthusiasm, and to the Shelley and Donald Rubin Foundation—I am deeply grateful for the generous support. To Cynthia Allen, who first planted the seeds for this a decade ago.

Linda Badami stepped in when I most needed someone to believe in the project and gave me guidance and deadlines.

Manuela Soares generously shared her expertise and directed the project to fruition in its final stages.

I also want to thank Stacee Lawrence of The Monacelli Press, who fell in love with this work the moment she opened the box, for being the editor one dreams of; Elizabeth White, for her dedication to reproducing the images so well; Su M. Manzi for her writing, integrity, and the hours she spent interviewing and transcribing. Elena Georgiou, poet extraordinaire, for making language a friend and holding my hand; Jennifer P. Borum for helping match language to experience. Steve Turtell for his poetry and last-minute editorial assistance. To Michael Beirut and Yve Ludwig for their extraordinary design work.

I thank the curators and institutions that have exhibited this work. Nelson Hancock, Daneyal Mahmood, Kashya Hildebrand, Asya Geisberg, Murray Guy, Bellwether, the Rencontres d'Arles Festival, Taj Forer and Michael Itkoff of Daylight Magazine, Sanjyot Mehandale and Carverlee Cary of UC Berkeley, James Millward of Georgetown University, Rachel Harris of the School of Oriental and African Studies, and Zaim Khenchelaoui. To Dalit Anolik and Jolaine Frizzell for their enthusiasm and care.

To Nan Goldin, thank you for believing in and encouraging me for two decades and for your vision as you shifted my perspective in this lifetime.

To my dearest friends, who have inspired and encouraged me with their genius, creativity and for showing me myself when I could not see. Mart Bailey, my deep water partner; Michael Cormier, my adopted brother for his wisdom and brilliance of the heart; Rayya Elias for her loyalty, love and fire; Monica Gilette for dancing even when the sky comes down; Melanie Hope for her poetry, depth, and knowing the meaning of time off; Nanou LeBlonde, my French sister, for her love and strength; Michael Naimy for infusing spirit into the everyday; elin o'Hara slavick for her passion and prolific relationship to art; my cousin D. Tucker Smith for her creative spirit, determination, and for being the big sister I never had. To Jaime, Justine, and Julia for making this world that much brighter. To David Hixon for your deep, daily confidence and love.

To my sister, Wendy, who I could not love more.

To Sherisse, whose quiet and gentle spirit can move mountains and for the poetry she weaves into each day.

Library of Congress Cataloging-in-Publication Data

Living shrines of Uyghur China/photographs by
Lisa Ross; essays by Beth Citron, Rahilä Dawut, and
Alexandre Papas.
p. cm.
ISBN 978-1-58093-350-6
1. Islamic shrines—China—Xinjiang Uygur Zizhiqu—
Pictorial works. 2. Uighur (Turkic people)—China—
Xinjiang Uygur Zizhiqu—Religion. 3. Muslim pilgrims and
pilgrimages—China—Xinjiang Uygur Zizhiqu. 4. Islam—
China—Xinjiang Uygur Zizhiqu—History. I. Ross, Lisa. II.
Citron, Beth. III. Dawut, Rahilä. IV. Papas, Alexandre.
BP187.55.C62X565 2013
297.3'5516—dc23 2012035784

Printed in Italy
www.monacellipress.com

10 9 8 7 6 5 4 3 2 1
First edition

Designed by Yve Ludwig, Pentagram